YESTERDAY'S TOYS

Celluloid Dolls, Clowns, and Animals

YESTERDAY'S TOYS

Celluloid Dolls, Clowns, and Animals

Teruhisa Kitahara ▪ Photography by Masashi Kudo

Chronicle Books ▪ San Francisco

First published in the United States in 1989 by Chronicle Books.

Copyright © 1988 by Graphic-sha Publishing Co., Limited. All rights reserved. No part of this book may be reproduced without written permission from the publisher.

Library of Congress Cataloging in Publication Data:

Kitahara, Teruhisa, 1948–
 [Yesterday of toys. Celluloids]
 Yesterday's toys. Celluloid dolls, clowns, and animals/Teruhisa
 Kitahara; photographs by Masashi Kudō.
 p. cm.
 Originally published: Yesterday of toys. Celluloids. Tokyo,
 Japan: Graphic-sha Pub. Co., ©1988.
 ISBN 0-87701-615-1
 1. Celluloid dolls—Private collections—Japan—Catalogs.
 2. Toys, Mechanical—Japan—Catalogs. 3. Kitahara. Teruhisa—
 Art collections. I. Kudō, Masashi. II. Title.
 TS2301.T7K476 1989
 688.7'221—dc20 89-17351
 CIP

Printed in Japan.

Cover design by Julie Noyes

Distributed in Canada by
Raincoast Books
112 East Third Avenue
Vancouver B.C. V5T 1C8

10 9 8 7 6 5 4 3 2 1

Chronicle Books
275 Fifth Street
San Francisco, California 94103

THE AGE OF CELLULOID

In the middle of the Meiji era (1868–1912), imported celluloid was worked by hand and used as a substitute for natural materials such as ivory, tortoiseshell, and coral. It was made into ornamental hairpins, eyeglass frames, billiard balls, and other objects. Later, new techniques were developed. The most important of these were:

Pressed Ball Molding: After the celluloid was cut into plate form, it was put in hot water. Once submerged, it was put between semicircular male and female dies, and molded by the heat of the water. The rough edges of the molded hemispheres were then removed, and the two hemispheres bonded together to make a sphere. Products manufactured by this technique included ping-pong balls, self-righting toys, and rattles.

Blow Molding: Celluloid plates were placed between heated male and female dies. Heated compressed air was then injected into the dies to mold the celluloid. The molding process was finished by cooling the dies quickly with water. To make it easier to remove products from the dies, they were coated with liquid soap, which was expensive at that time. This was the forerunner of present blow-molding techniques. Most hollow products—such as Kewpie dolls—were manufactured by this method.

Competing with toys made of traditional materials such as clay, wood, paper, and cloth, celluloid dolls and toys were introduced on a full scale in the late Meiji and early Taisho eras (there are records of celluloid toys being sold in Japan in 1913, but the type of product is unknown). In that age, with the lingering atmosphere of the Edo period, it is easy to imagine people being captivated by this light, versatile, easy-to-color material. The age of celluloid was created overnight. In addition to its beauty and popularity, celluloid had another advantage: camphor, its main ingredient, was cheap, because it was a product of Taiwan. During World War I, Germany, the principal exporter of celluloid toys, halted its production of toys, and this provided Japan with the opportunity to meet world needs. After World War I, there was a sluggish period, but in 1927 and 1928, Japanese production rose to become the highest in the world.

Celluloids were found everywhere in daily life, although their inflammability was a disadvantage: celluloid was used for pen cases, writing boards, subway ticket holders, pails, wash bowls, rulers, bathtub toys, teething rings—the list goes on and on.

However, as the war front in China expanded, the supply of materials for celluloid became short, and with the outbreak of World War II in 1941, production of celluloid dolls and toys stopped completely.

Manufacturers resumed production right after the war. This met the needs of Japanese children hungry for playthings; and supported by a now-unbelievable exchange rate, celluloid exports grew to be the most significant area of total Japanese toy production.

After that, in addition to prewar designs, new products were developed combining special mechanisms with celluloid. This resulted in a string of remarkable products—there were dancing dolls, merry-go-rounds, crawling dolls, and many other toys with new functions. These products quickly helped overcome some of Japan's postwar economic problems. They were actively exported all over the world to obtain foreign currency, each bearing the notification "Made in OCCUPIED Japan."

But soon, celluloid's one defect—its inflammability—became an issue overseas. Non-flammable and flame-resistant celluloids were studied around 1950. In the mid-fifties, the problem was solved by the birth of plastics.

Mr. Kitahara, an enthusiastic, world-famous collector of metal toys, is now publishing this book about the celluloid dolls and toys he has collected. It is very rare to find such a wealth of material on inflammable and breakable celluloid. We respect his passion for preserving these rapidly disappearing toys and applaud his books.

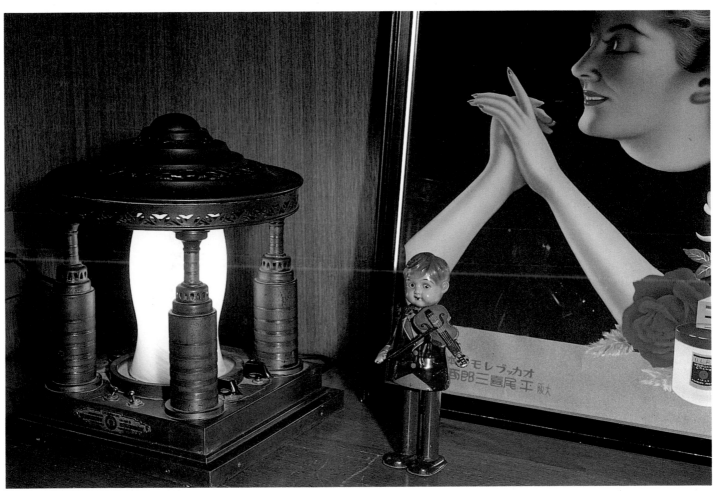

❶ 11×7×21.5/UNKNOWN/W/1930'S

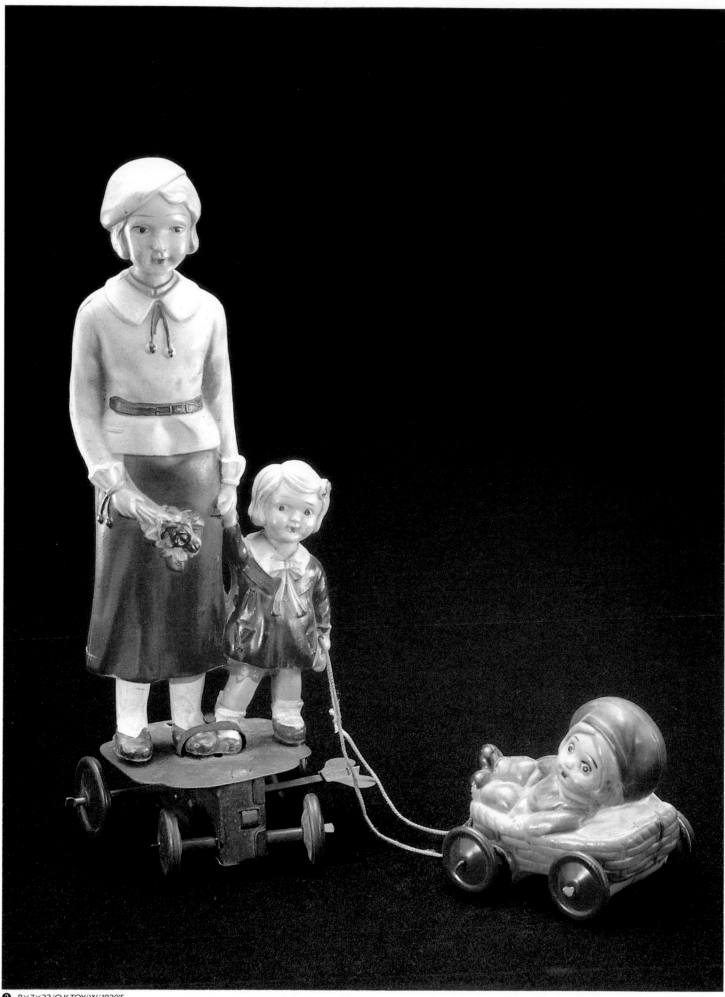

❷ 8×7×22／O.K.TOY／W／1930'S

❸ 5.5×6×15/UNKNOWN/W/1930'S

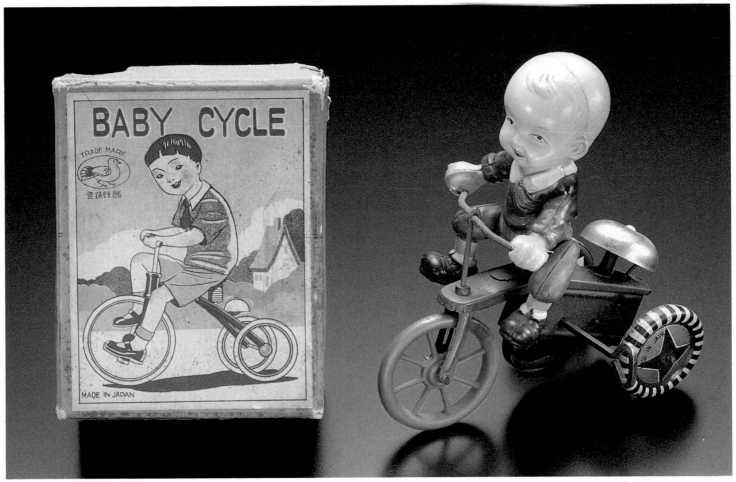

❹ 7×12.5×15/UNKNOWN/W/1930'S

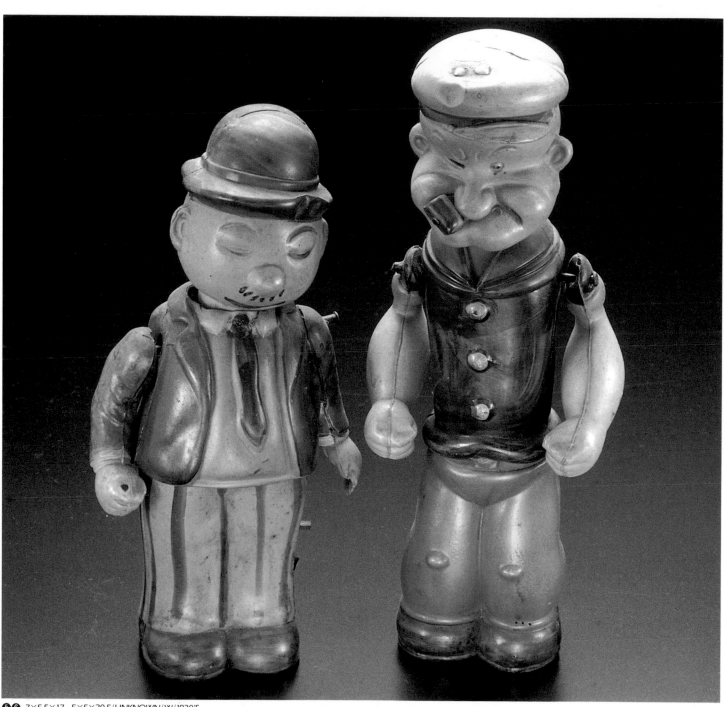

❺❻ 7×5.5×17, 5×5×20.5/UNKNOWN/W/1930'S

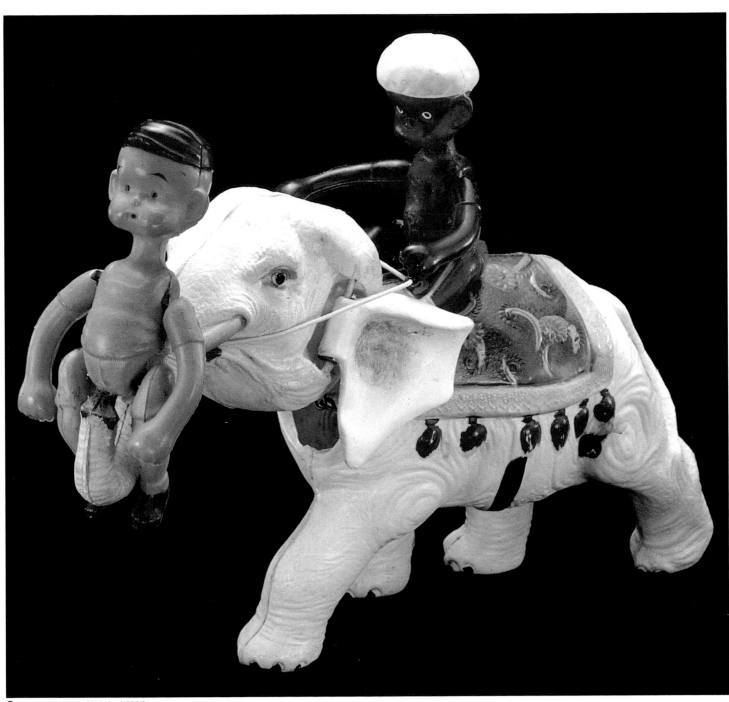

❼ 6×22×16/UNKNOWN/W/1930'S

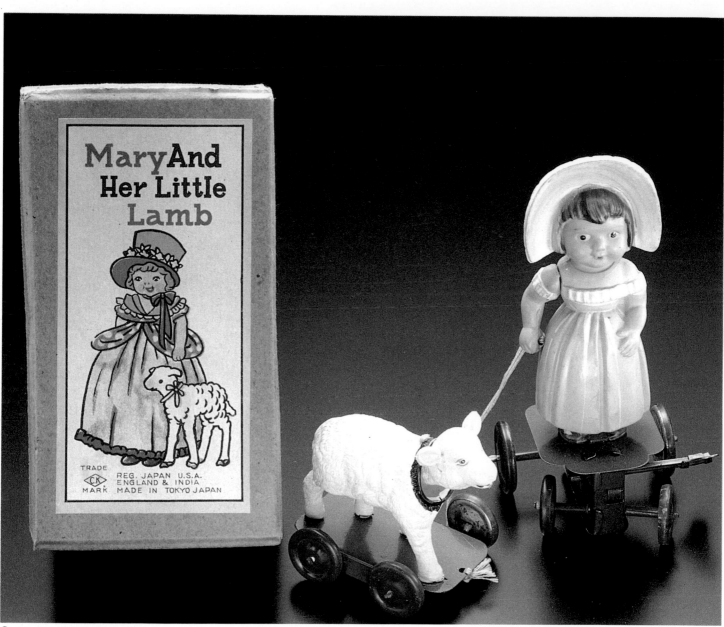

8 6.5×7×14/KURAMOCHI/W/1930'S

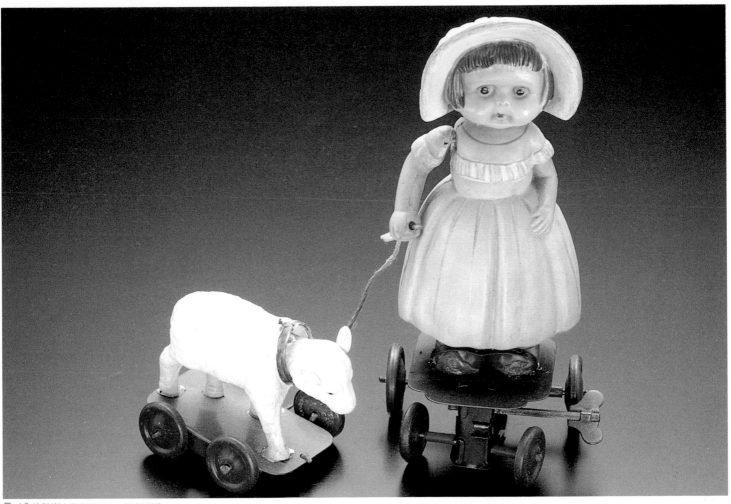

⑨ 6.5×6.5×16.5/KURAMOCHI/W//1930'S

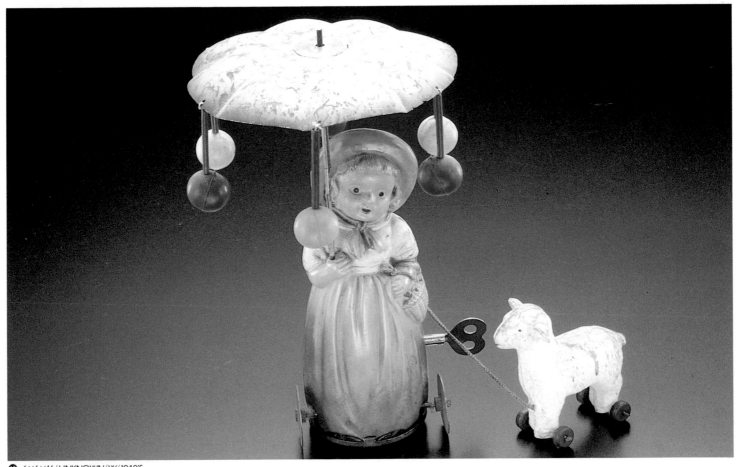

⑩ 6×6×16/UNKNOWN/W//1940'S

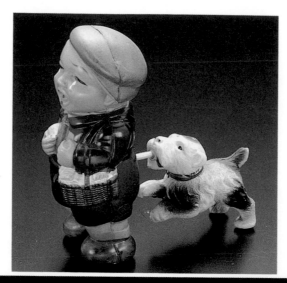

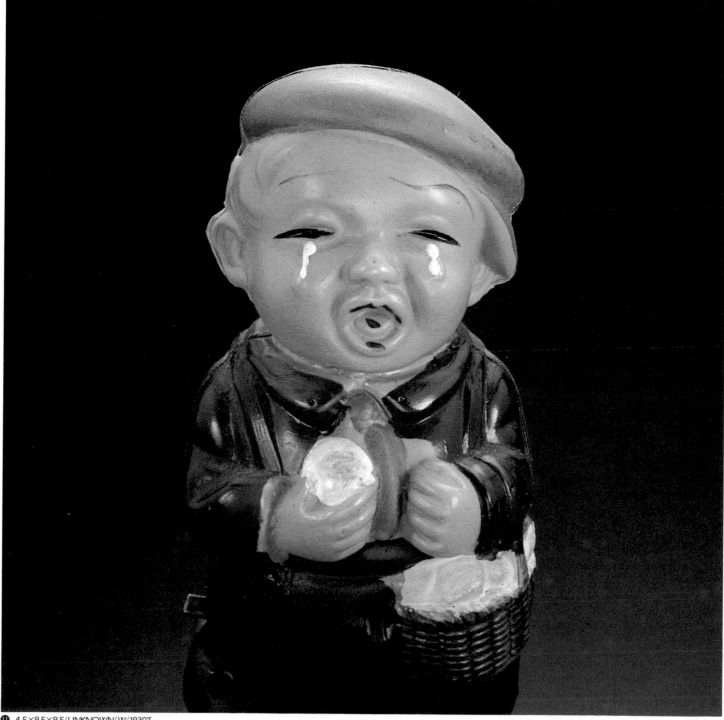

⓫ 4.5×9.5×9.5/UNKNOWN/W/1930'S

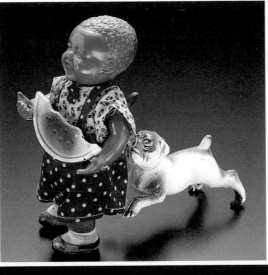

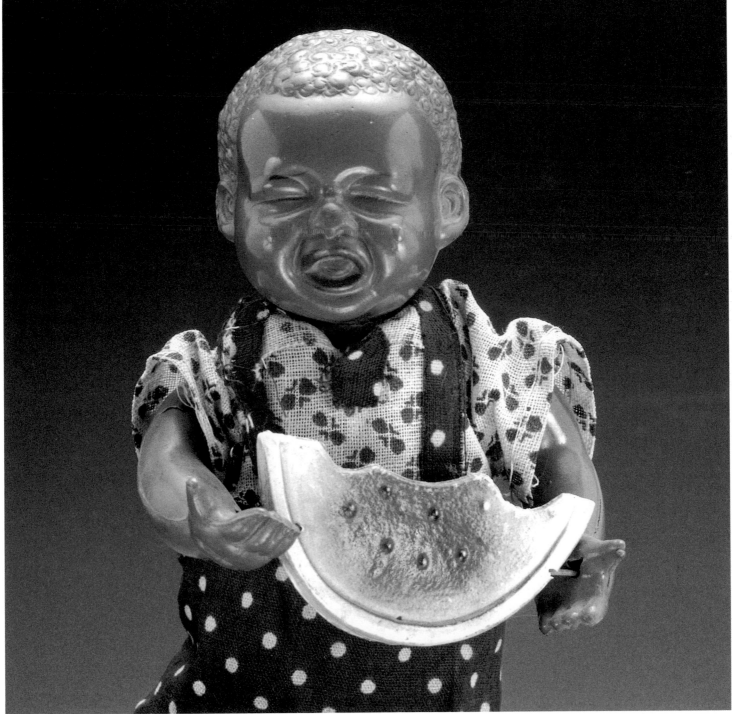

⑫ 7×15×14.5/UNKNOWN/W//1930'S

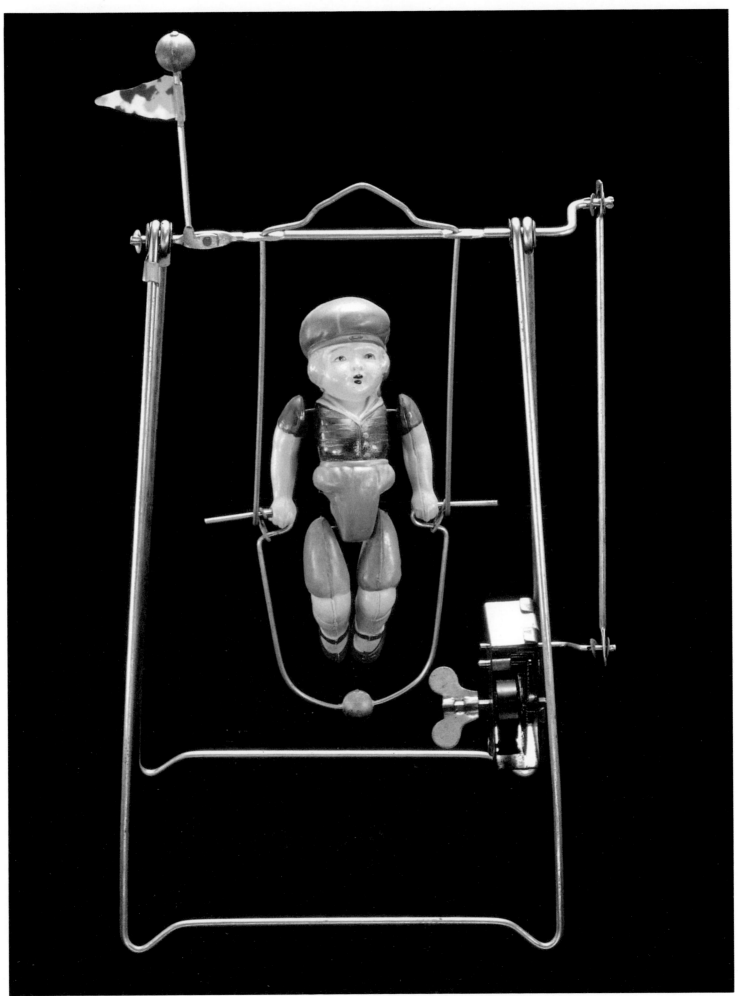

⑱ 13.5×8×23/KURAMOCHI/W/1930'S

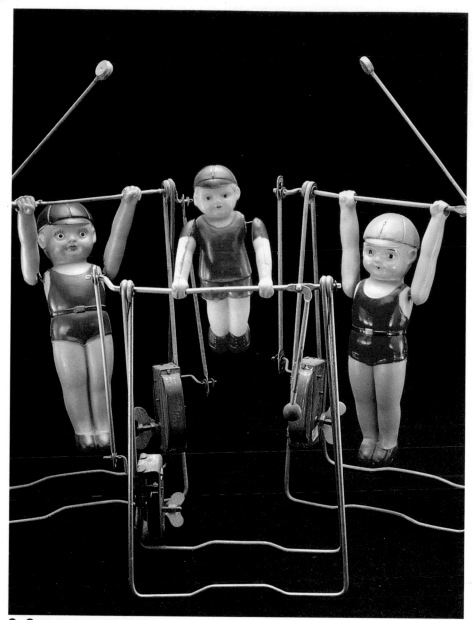

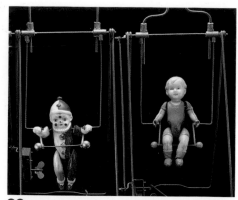

⓱⓲ 14.5×20×44, 14.5×23×43/UNKNOWN/W/1930'S

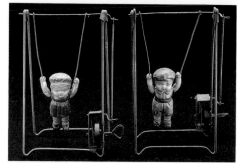

⓳⓴ 10×3×17/UNKNOWN/W/1930'S

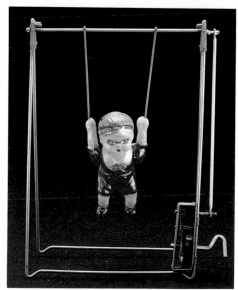

㉑ 13×3×16/UNKNOWN/W/1940'S

⓮～⓰ 14×6×22/UNKNOWN/1930'S

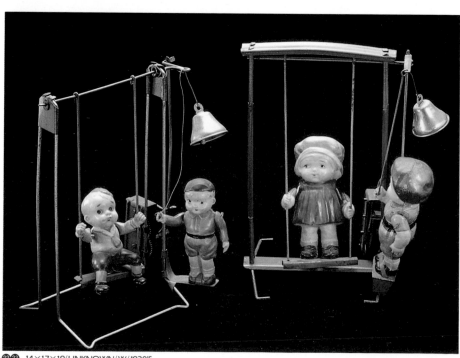

㉒㉓ 14×17×19/UNKNOWN/W/1930'S

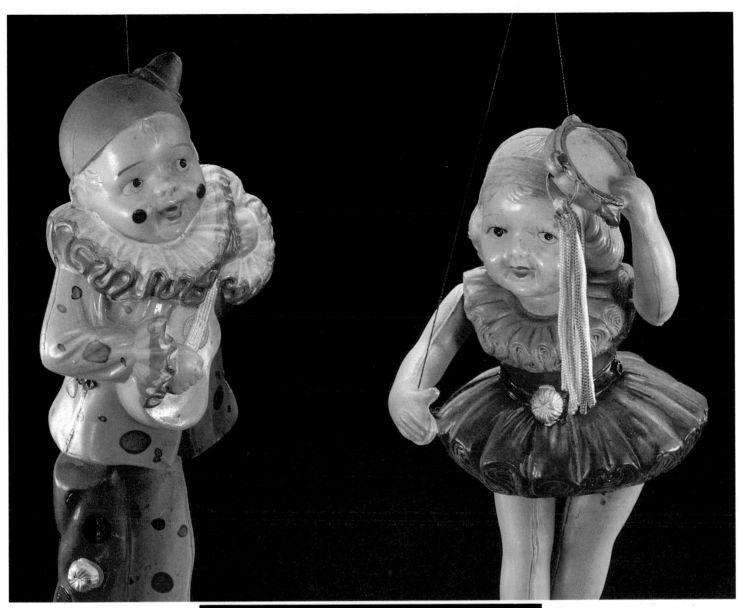

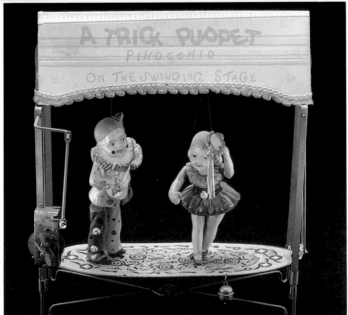

㉔ 22.5×11×28/KURAMOCHI/W/1930'S

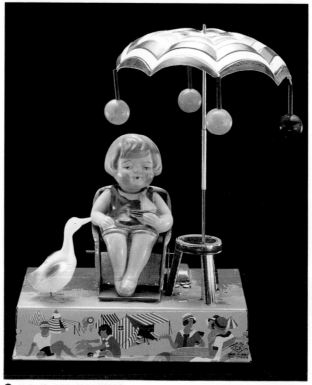

㉕ 16.5×12×25/ALPS/W/1930'S

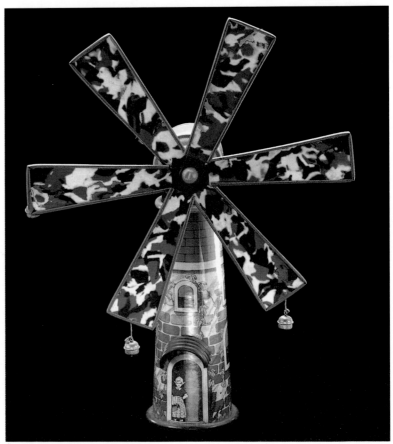

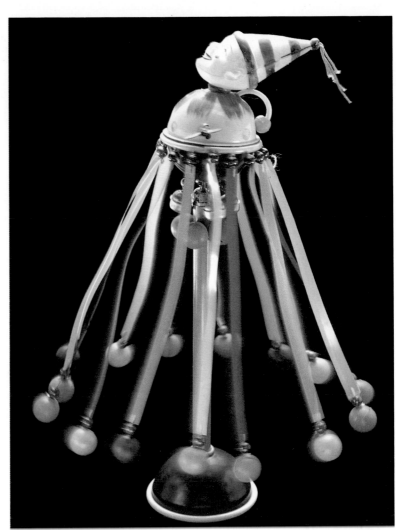

26 8.5×8×33.5/UNKNOWN/W/1930'S

27 24.5×8×33/KURAMOCHI/W/1930'S

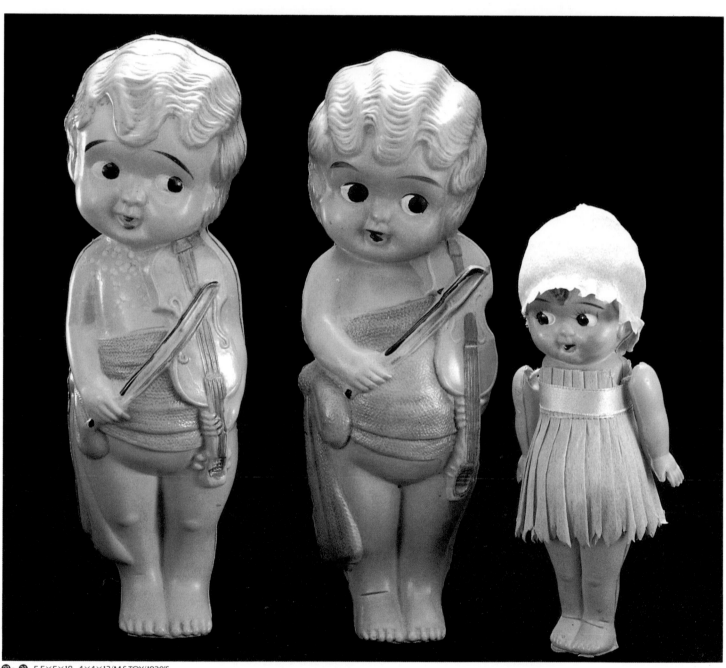

㉘～㉚　5.5×5×18，4×4×13/M.S.TOY/1930'S

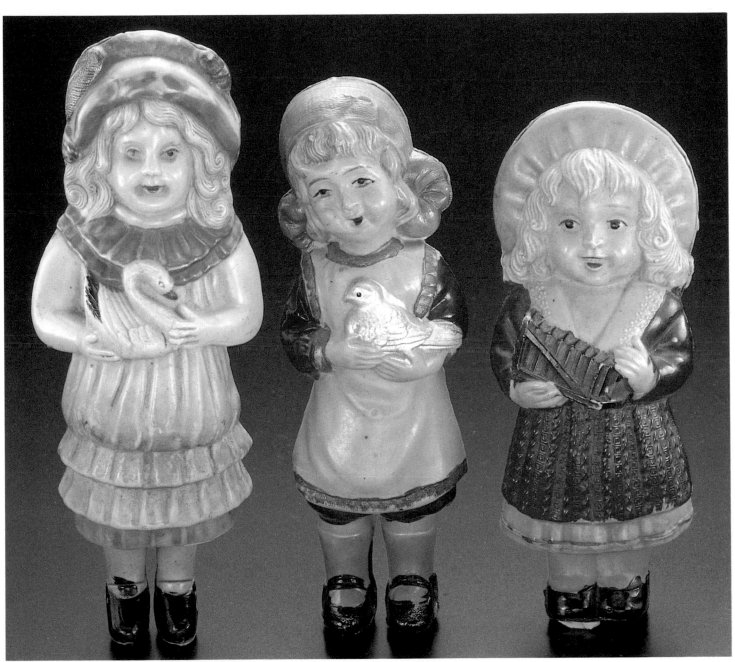

③1~③3 5×4×14.5, 4×3×12.5, 4×3.5×12/UNKNOWN/1930'S

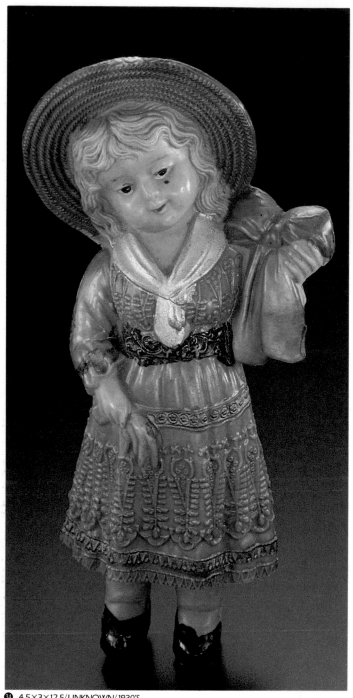

❸❹ 4.5×3×12.5/UNKNOWN/1930'S

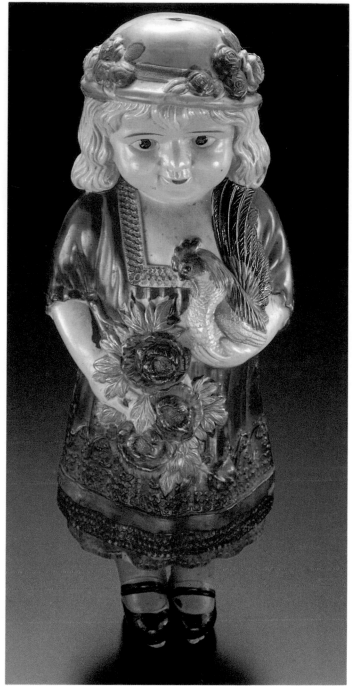

❸❺ 7×6.5×20/UNKNOWN/1930'S

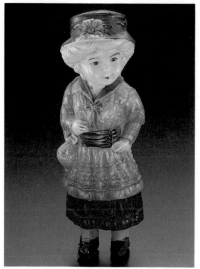

❸❻ 5×4×15.5/UNKNOWN/1930'S

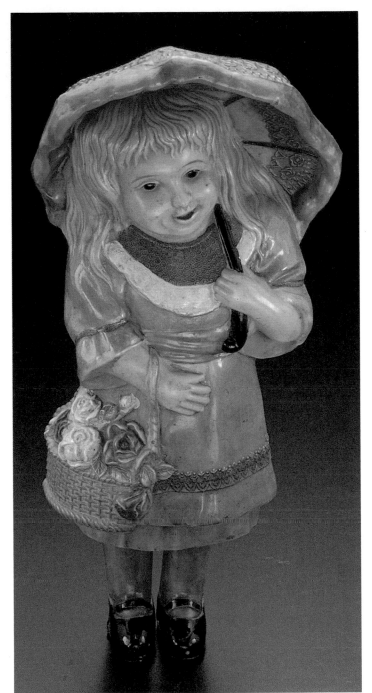

38 8×5×18/UNKNOWN/1930'S

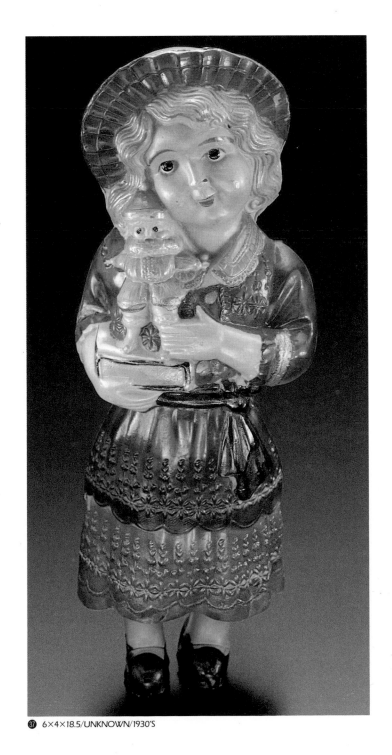

37 6×4×18.5/UNKNOWN/1930'S

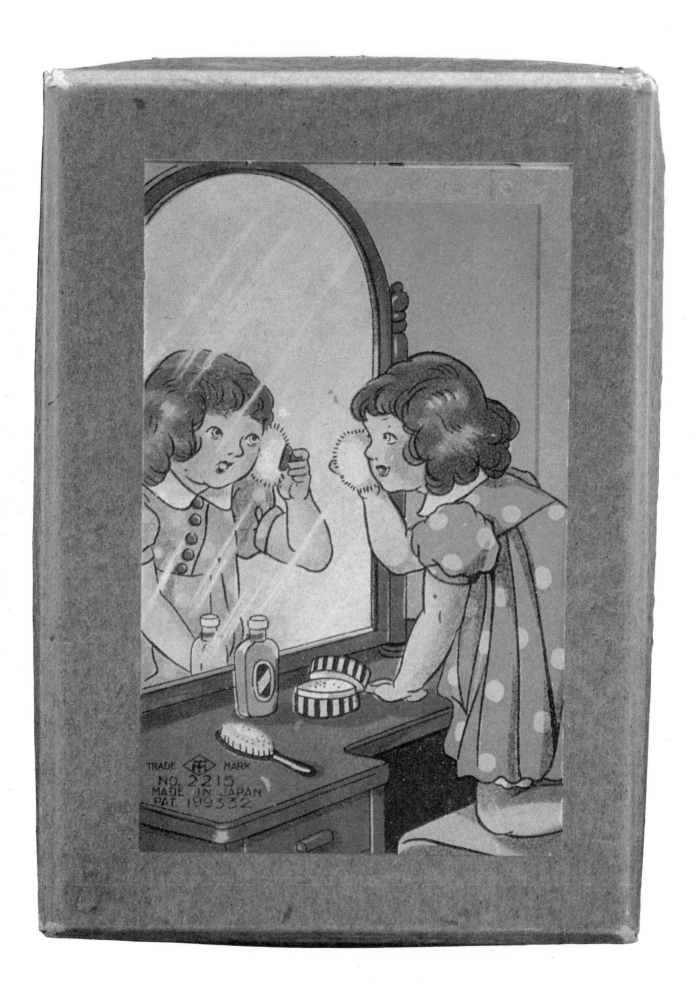

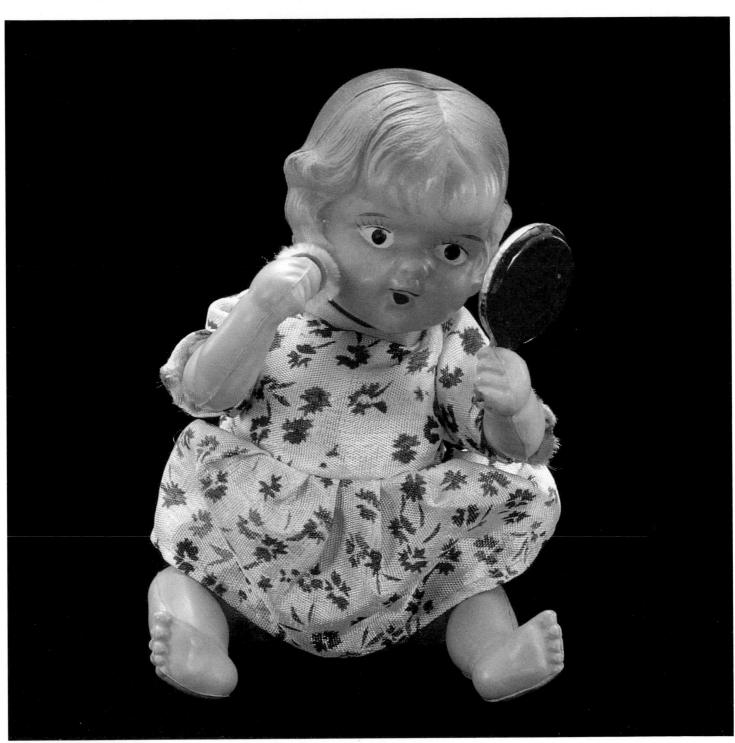

㊴ 9×7×13/MASUDAYA/W/1930'S

④ 10.5×8×24.5/UNKNOWN/1930'S

④ 12×12×20/UNKNOWN/1930'S

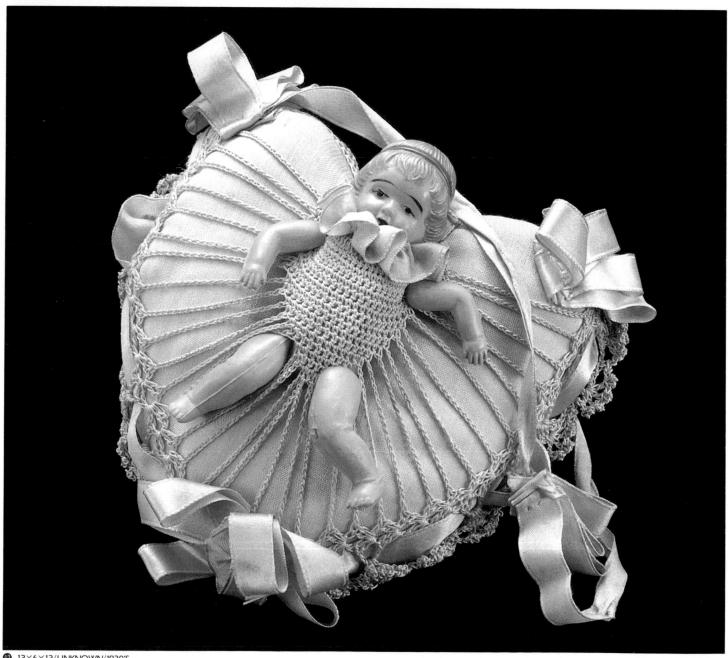

④ 13×6×13/UNKNOWN/1930'S

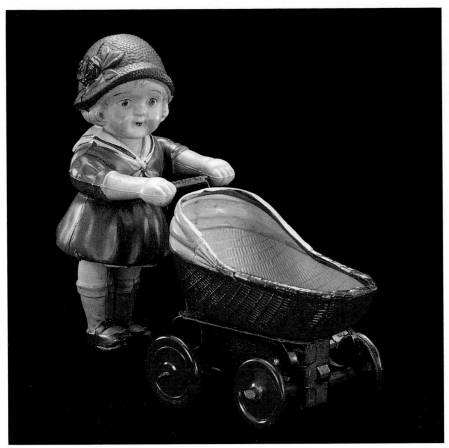

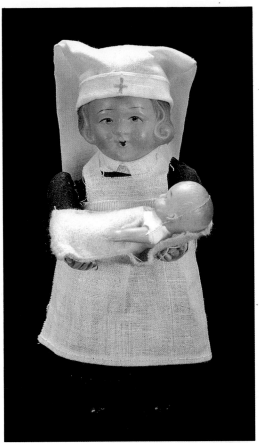

㊸ 7×15×13/UNKNOWN/W//1930'S

㊹ 5×9×13.5/UNKNOWN/W//1930'S

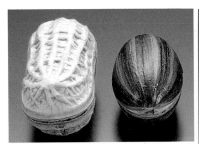

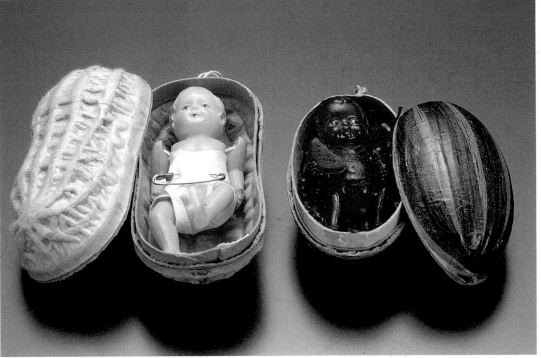

㊺㊻ 5×6×10, 4.5×5×8/MARUGANE/1930'S

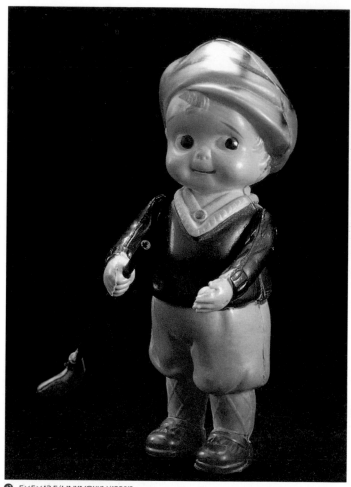

❹ 5×5×12.5/UNKNOWN/1930'S

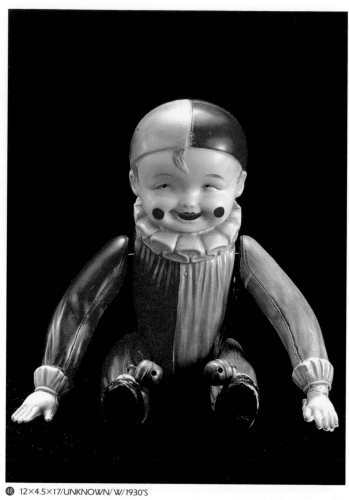

❹ 12×4.5×17/UNKNOWN/W/1930'S

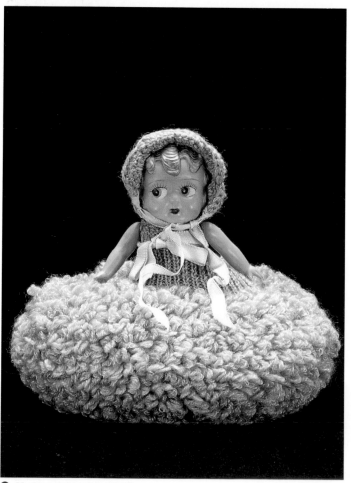

❹ 22×20×19/UNKNOWN/1930'S

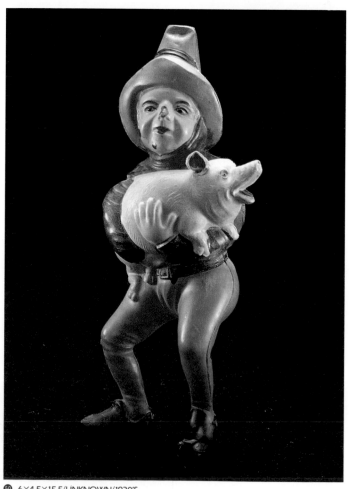

❺ 6×4.5×15.5/UNKNOWN/1930'S

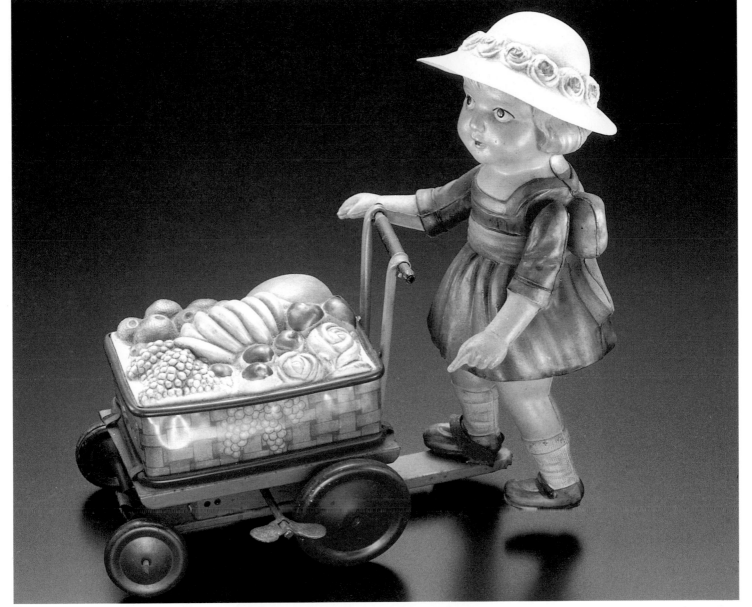

🔵 17×7×17/KURAMOCHI/W//1930'S

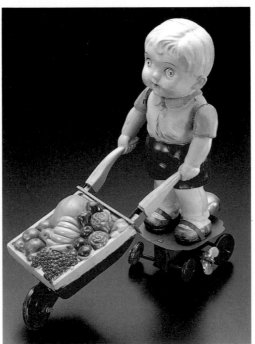

㉜ 19×7×21.5/KURAMOCHI/W//1930'S

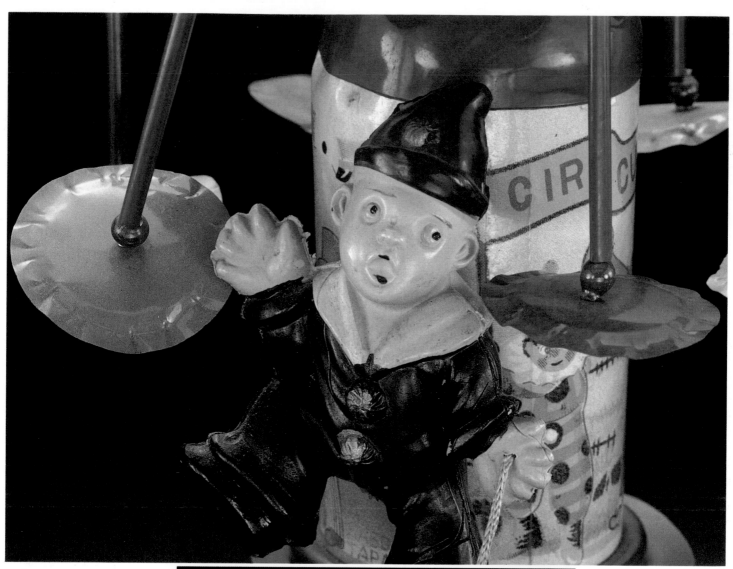

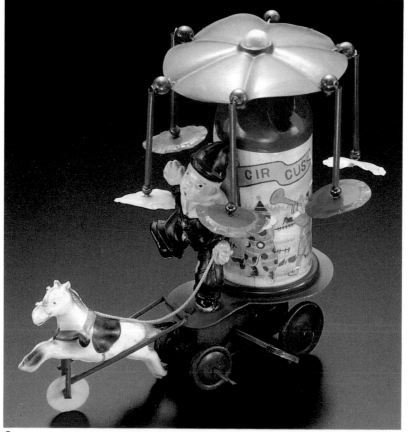

❸ 15×6×15/UNKNOWN/W//1930'S

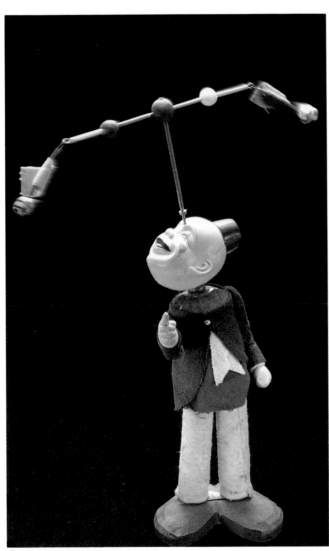

㉟ 10×8.5×36/KURAMOCHI/W//1930'S

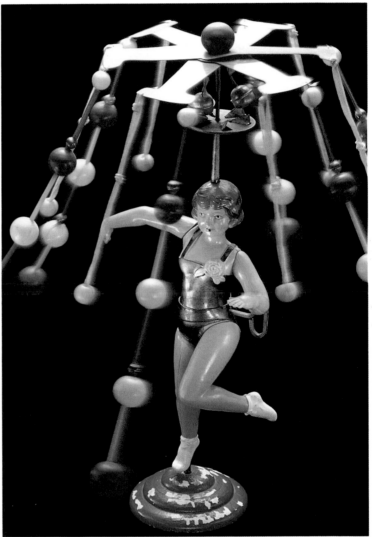

㉟ 14×14×31/KURAMOCHI/W/1930'S

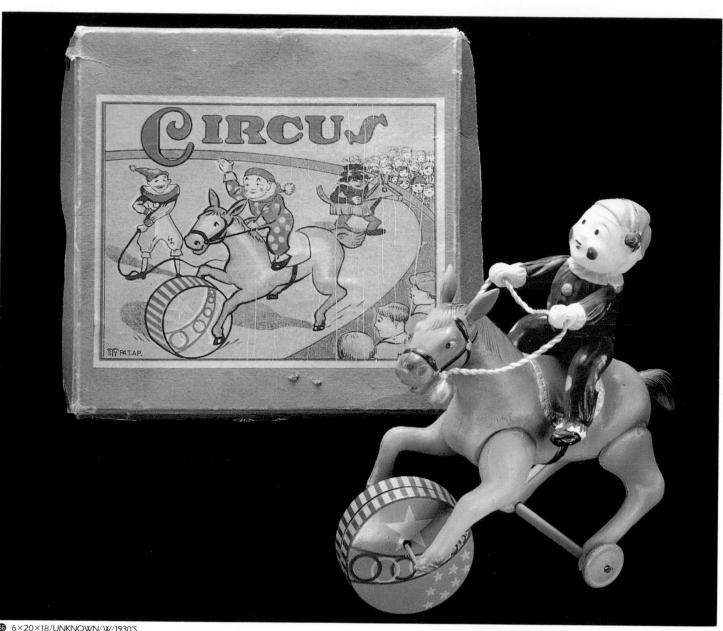

56 6×20×18/UNKNOWN/W/1930'S

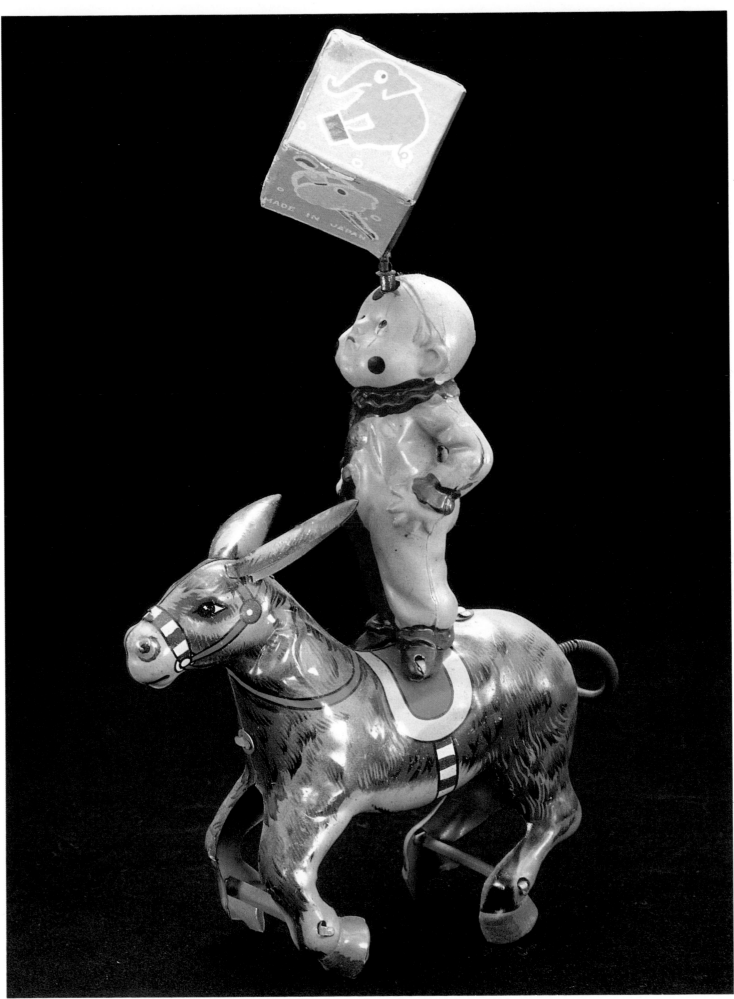

❺ 5×12×21/KURAMOCHI/W/1930'S

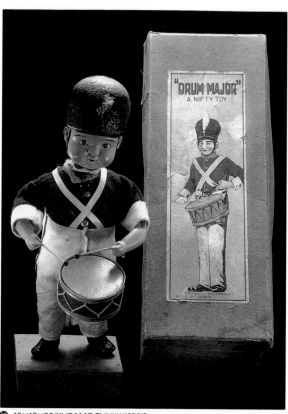

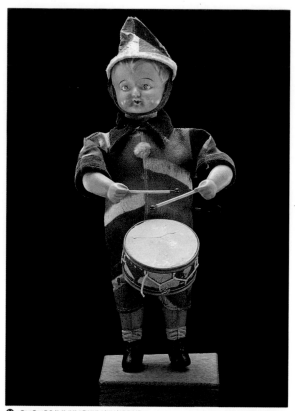

58 13×12×30/KURAMOCHI/W/1930'S

59 9×8×30/UNKNOWN/W/1930'S

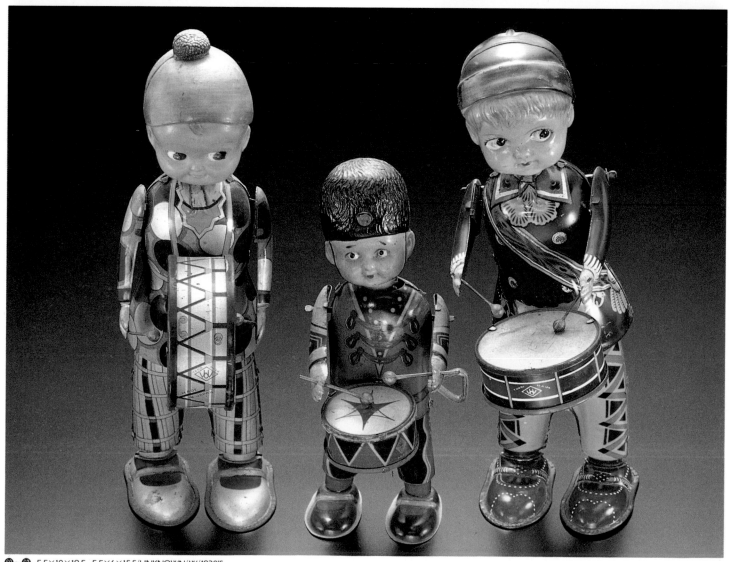

60～**62** 5.5×10×19.5, 5.5×6×15.5/UNKNOWN/W/1930'S

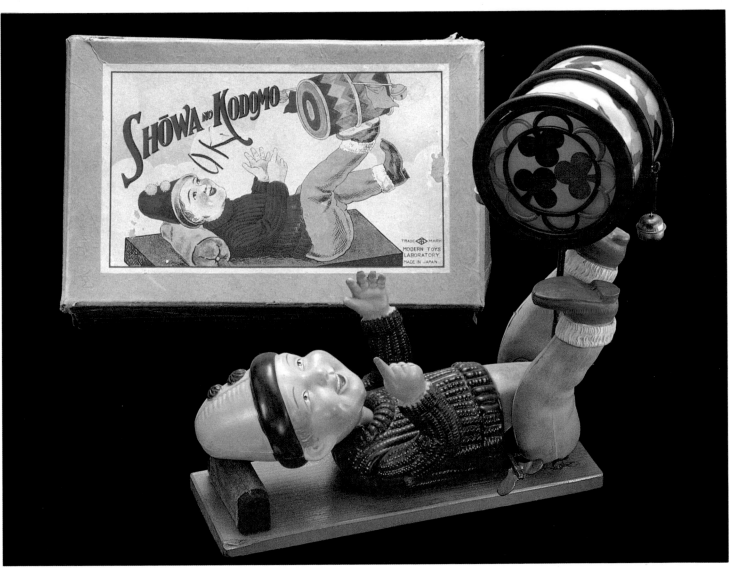

63 7×21×23/MASUDAYA/W//1930'S

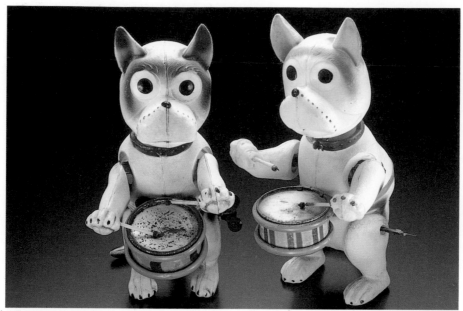

64 65 11×12×21.5/UNKNOWN/W/1930'S

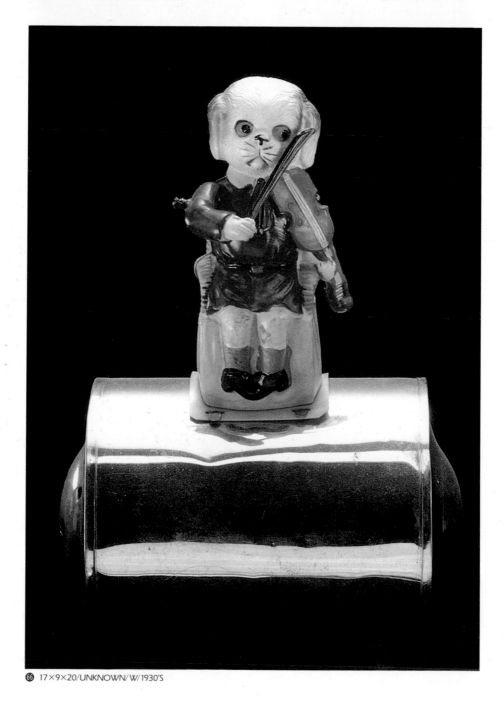

66 17×9×20/UNKNOWN/W/1930'S

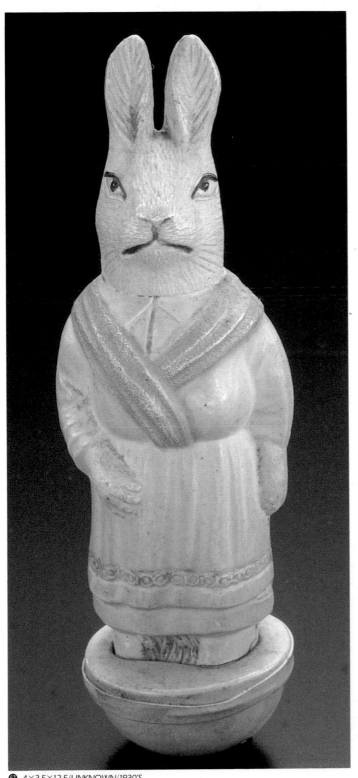

❻ 4×3.5×12.5/UNKNOWN/1930'S

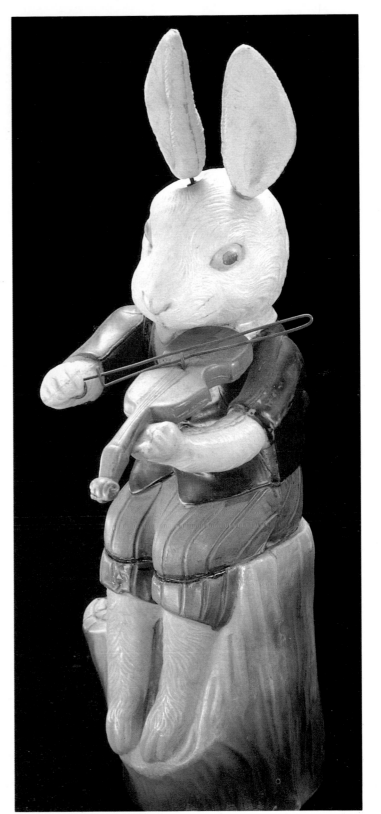

❽ 7.5×7×24/KURAMOCHI/W//1930'S

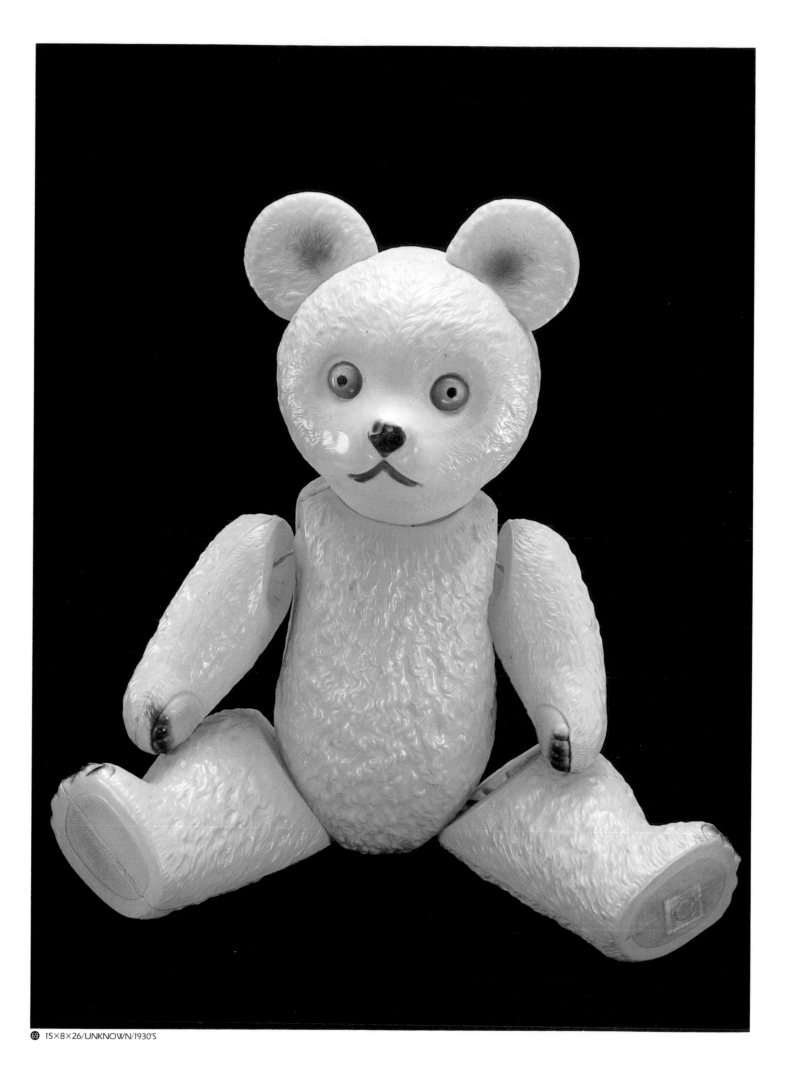

69 15×8×26/UNKNOWN/1930'S

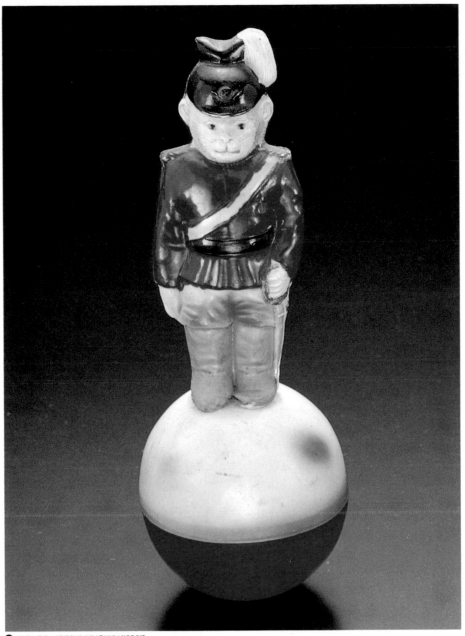

⑦ 5.5×5.5×15.5/UNKNOWN/1930'S

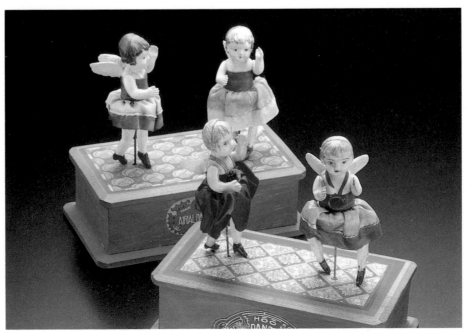

⑦⑦ 15×8.5×14/UNKNOWN/1930'S

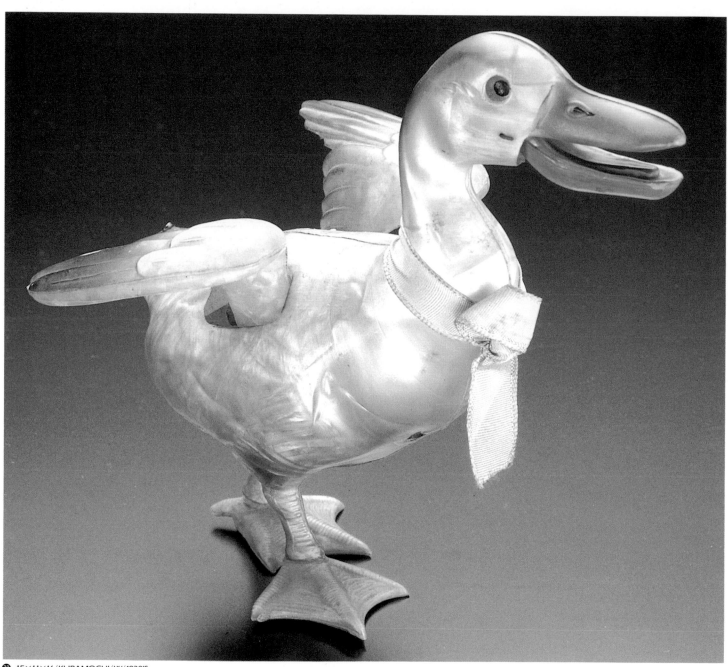

❼❸ 15×11×16/KURAMOCHI/W/1930'S

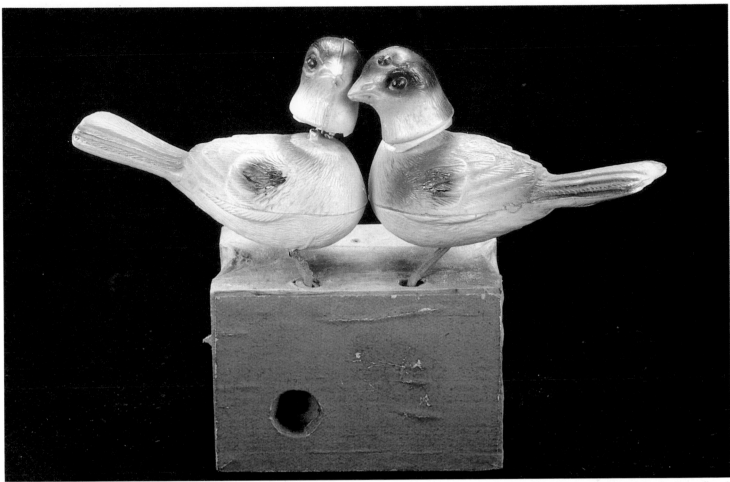

74 12×4×8.5/UNKNOWN/1930'S

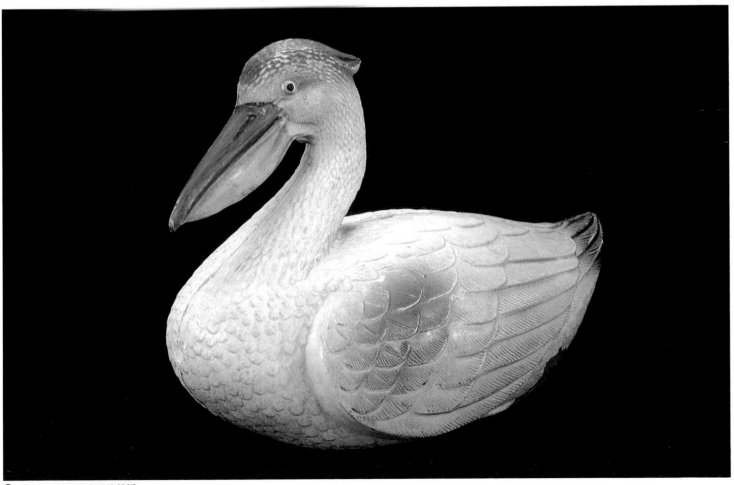

75 7.5×14×10/UNKNOWN/1930'S

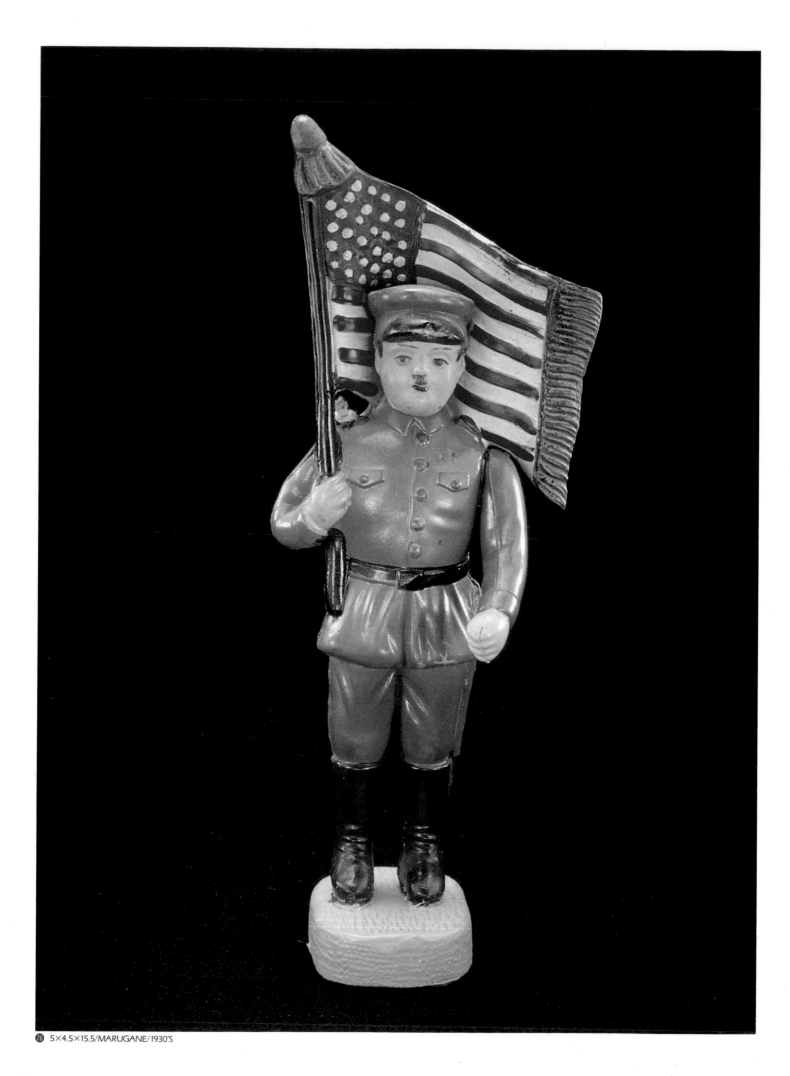

⑦6 5×4.5×15.5/MARUGANE/1930'S

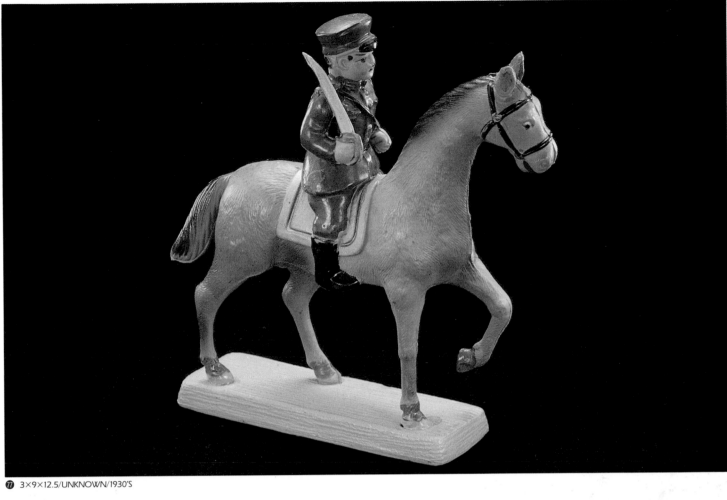

⑦ 3×9×12.5/UNKNOWN/1930'S

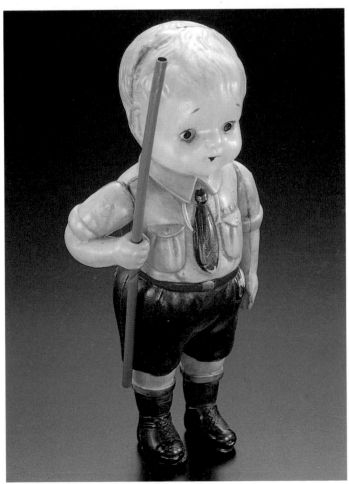

⑱ 6.5×5×15/MARUGANE/1930'S

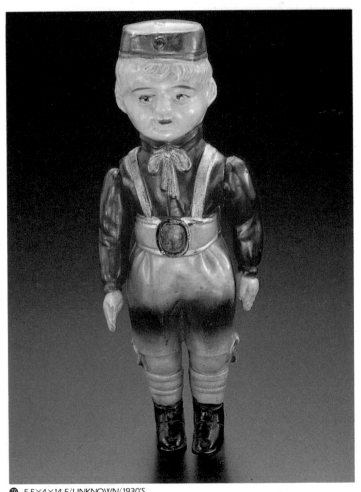

⑲ 5.5×4×14.5/UNKNOWN/1930'S

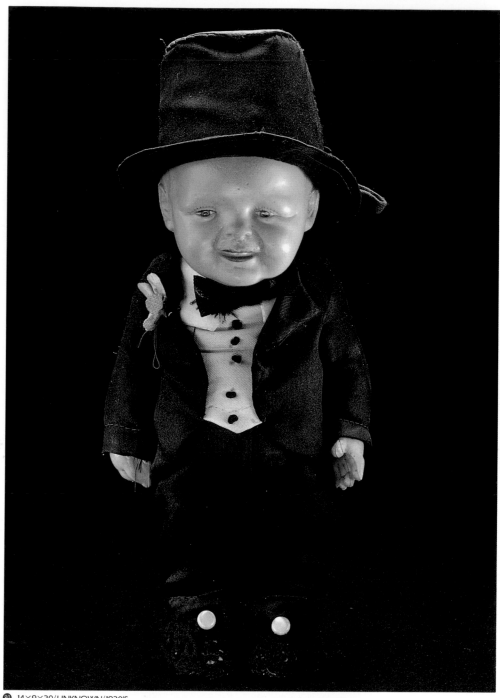

⑧⓪ 14×9×30/UNKNOWN/1930'S

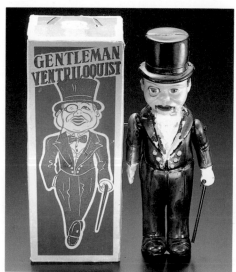

⑧① 6.5×4.5×17/KURAMOCHI/W/1930'S

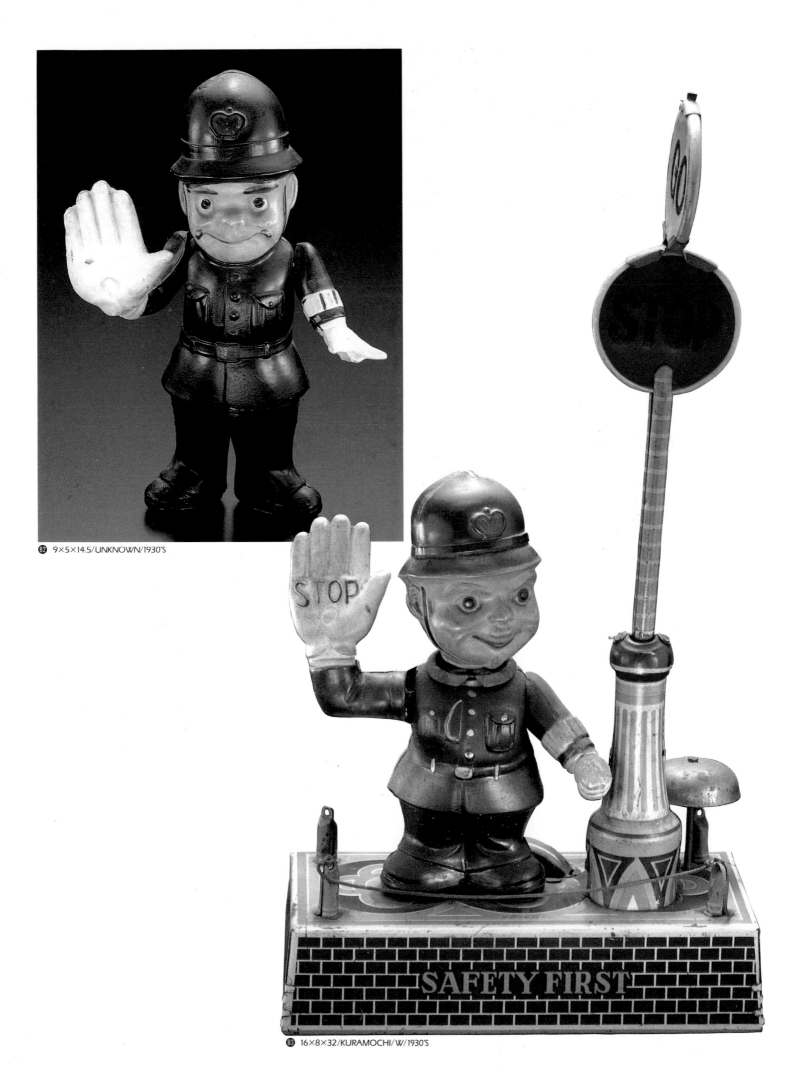

⑧ 9×5×14.5/UNKNOWN/1930'S

⑧ 16×8×32/KURAMOCHI/W/1930'S

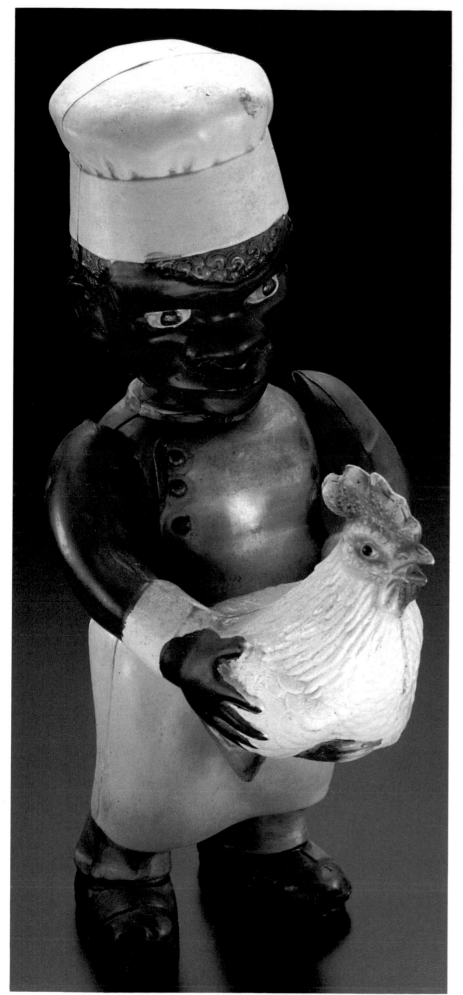

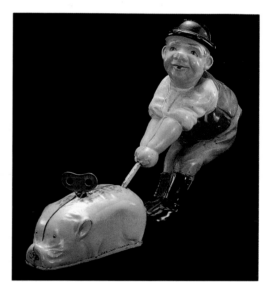

85　3.5×18×14/K.T.TOY/W/1930'S

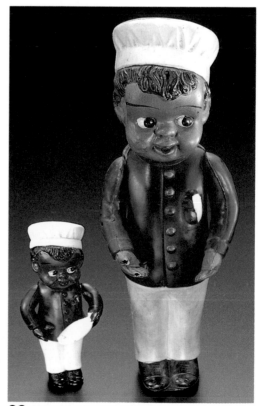

84　5.5×11×20/UNKNOWN/W/1930'S

86 87　2.5×2.5×9.5, 5×5×19.5/UNKNOWN/1930'S

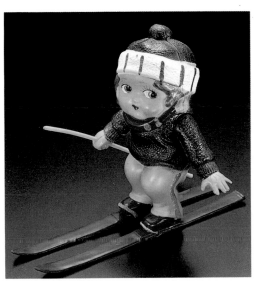

88 4×16×13.5/UNKNOWN/1930'S

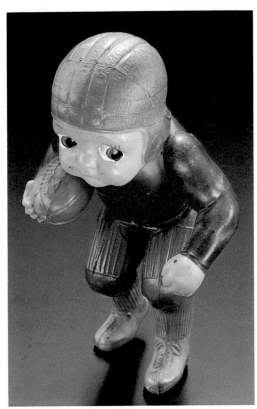

89 8.5×7×14.5/UNKNOWN/1930'S

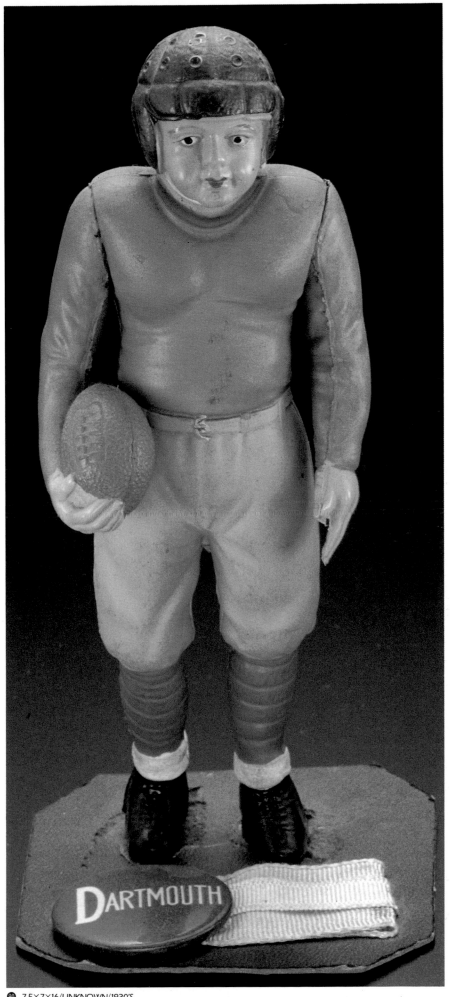

90 7.5×7×16/UNKNOWN/1930'S

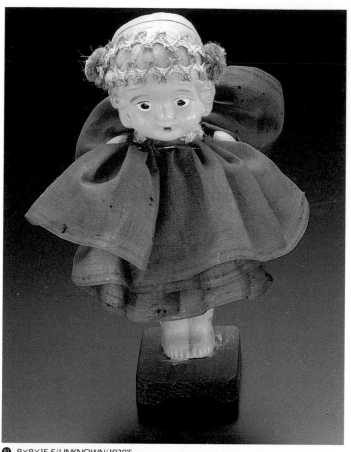

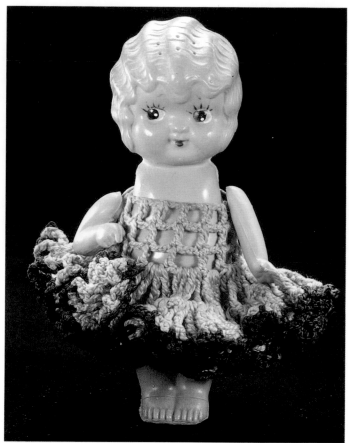

91 9×9×15.5/UNKNOWN/1930'S

92 9×9×12.5/UNKNOWN/1930'S

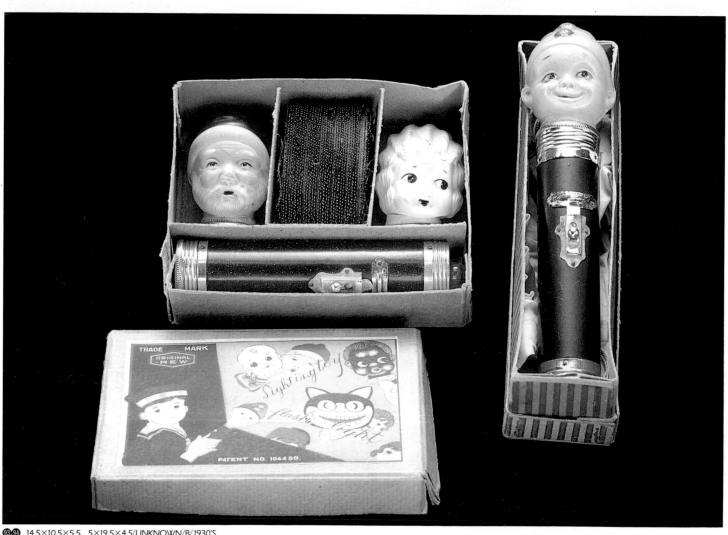

93·94 14.5×10.5×5.5, 5×19.5×4.5/UNKNOWN/B/1930'S

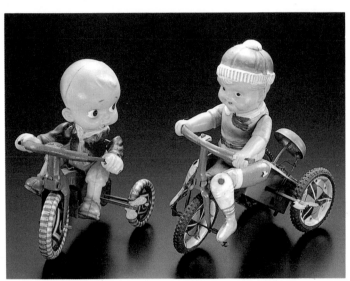

95 96 8.5×12.5×16, 7×14.5×17/UNKNOWN/W/1930'S

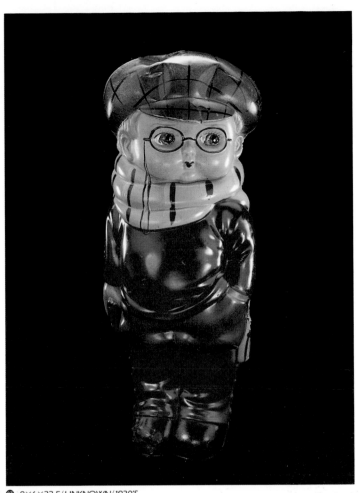

97 8×6×22.5/UNKNOWN/1930'S

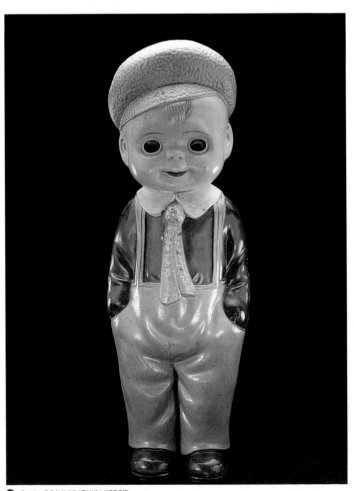

98 9×6×30/UNKNOWN/1930'S

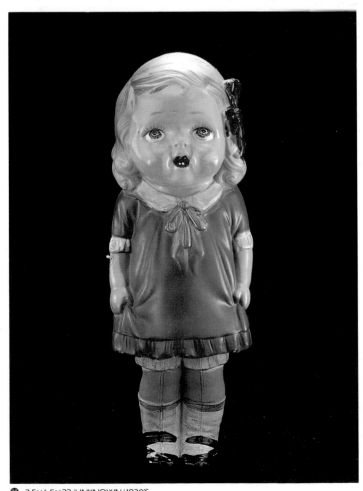

99 7.5×6.5×22/UNKNOWN/1930'S

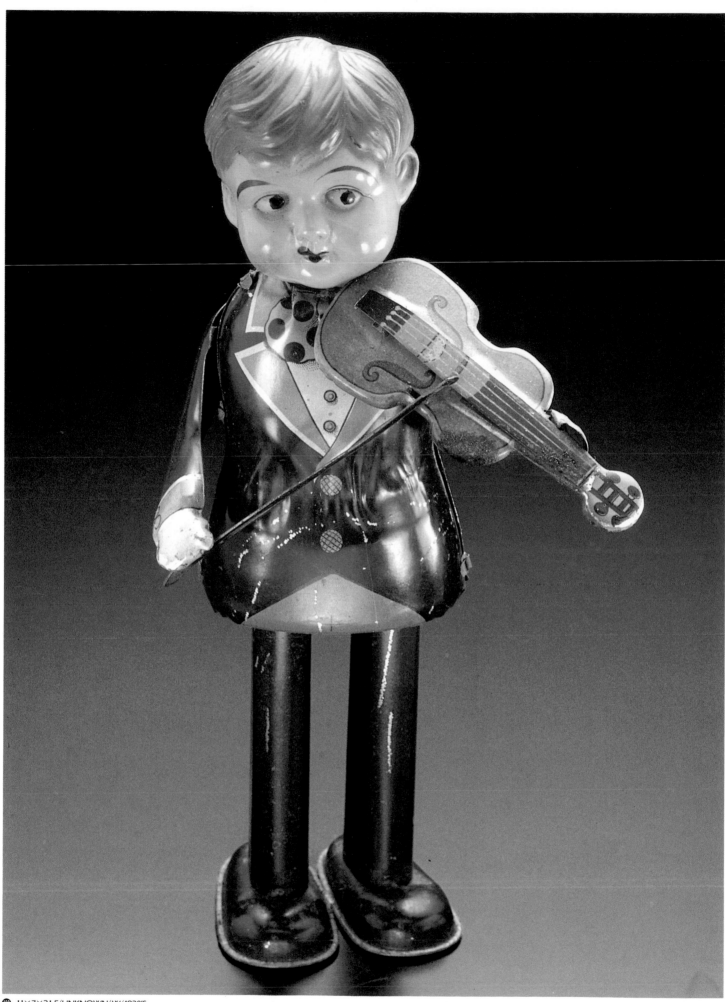

100 11×7×21.5/UNKNOWN/W/1930'S

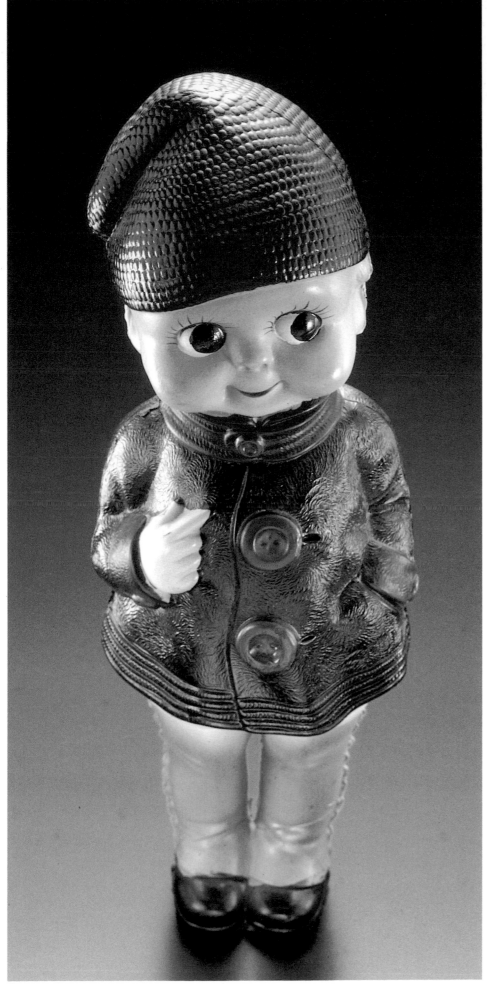

❶ 8×6×22.5/UNKNOWN/1930'S

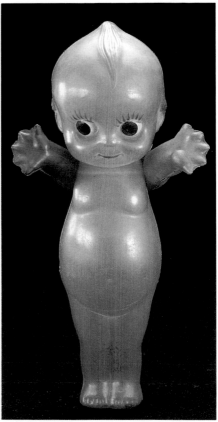

❷ 4×4×15.5/UNKNOWN/1930'S

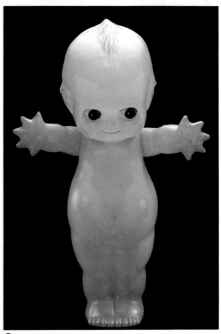

❸ 10×8×34/UNKNOWN/1930'S

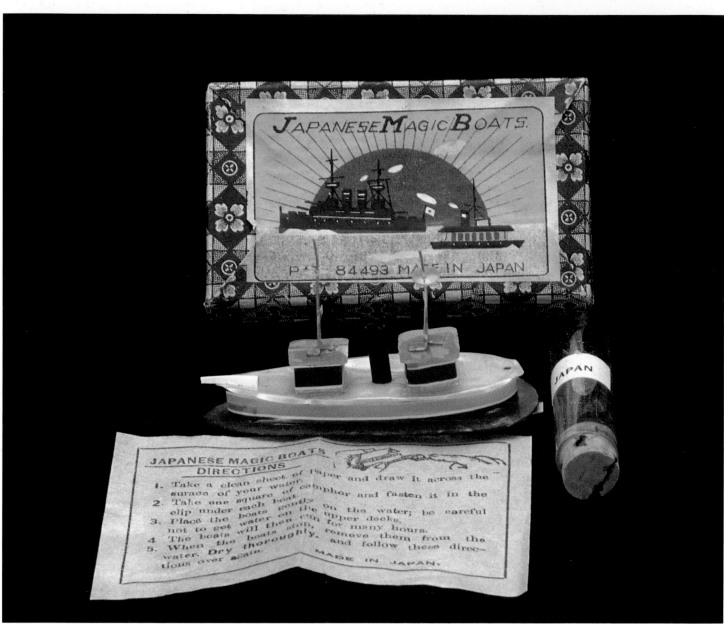

104 8×4.5×2.5/UNKNOWN/1930'S

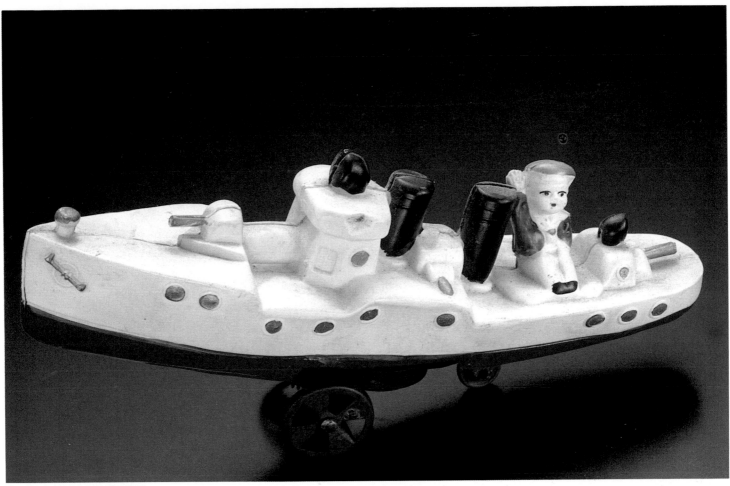

● 19×4.5×8/UNKNOWN/W/1930'S

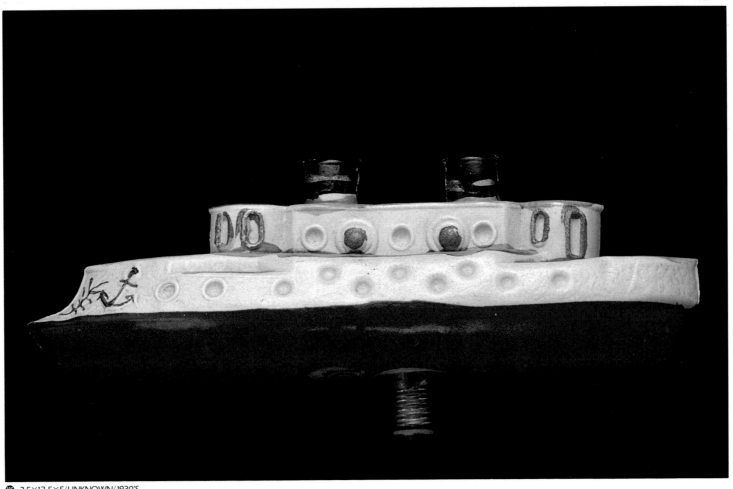

● 3.5×12.5×5/UNKNOWN/1930'S

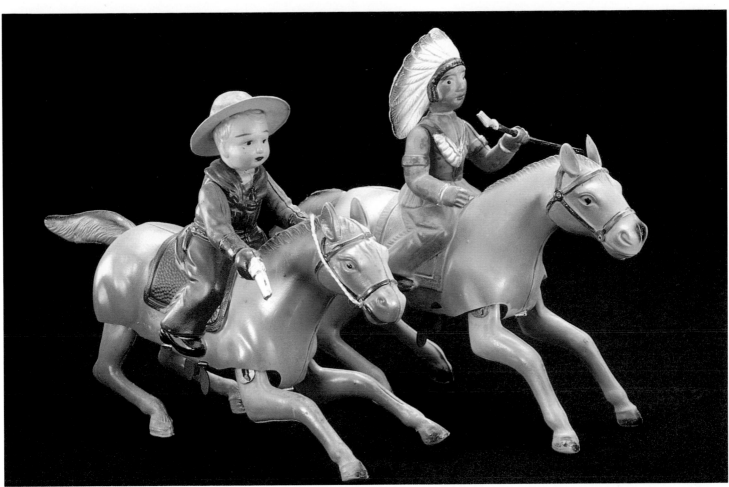

107·108 5×19×17/UNKNOWN/W/1930'S

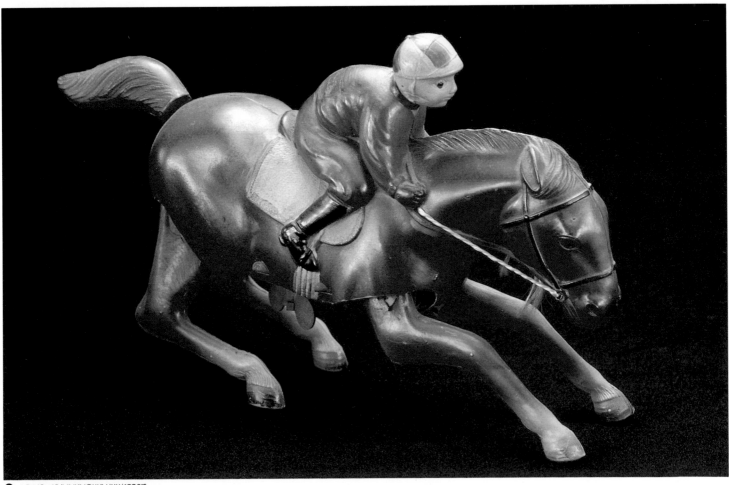

109 4.5×18×13/UNKNOWN/W/1930'S

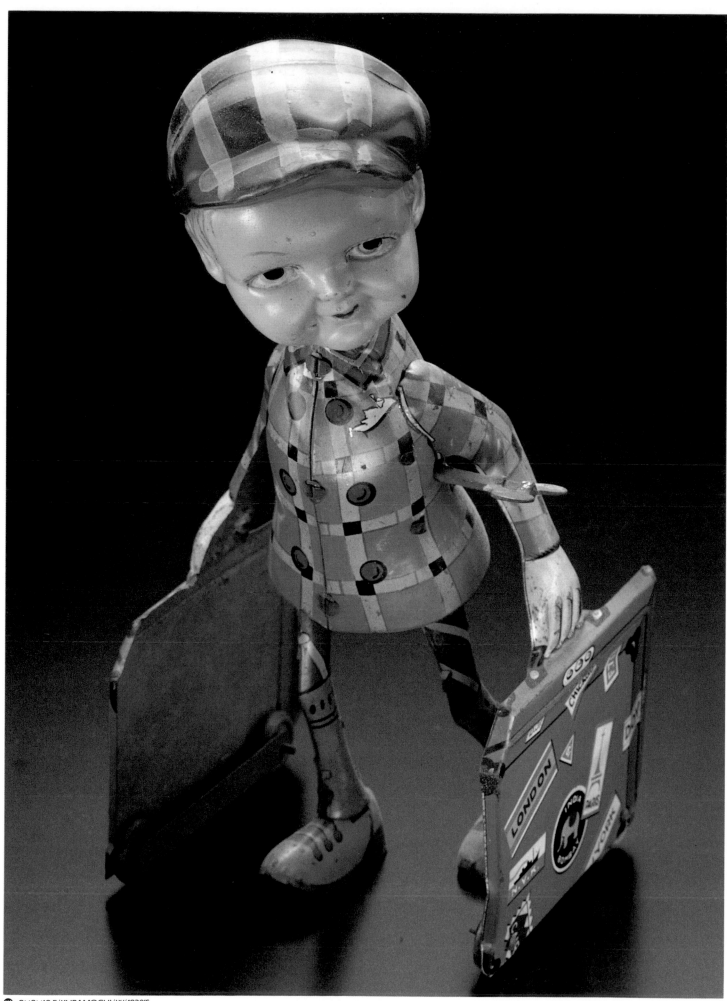

110 9×8×19.5/KURAMOCHI/W//1930'S

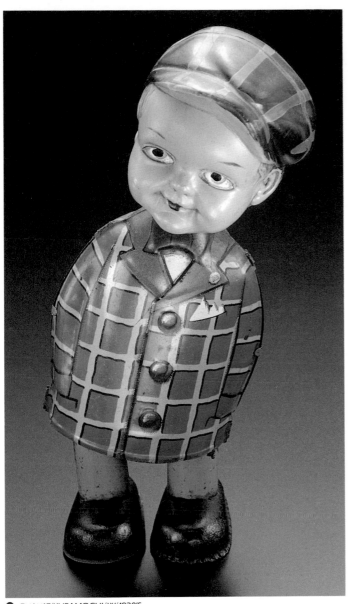

⑪ 7×6×17/KURAMOCHI/W//1930'S

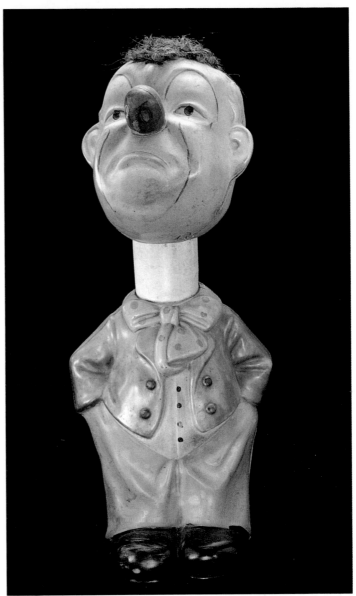

⑫ 7.5×6×20/KURAMOCHI/W//1930'S

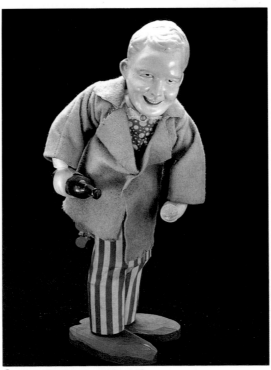

⑬ 14×10×30/UNKNOWN/W//1930'S

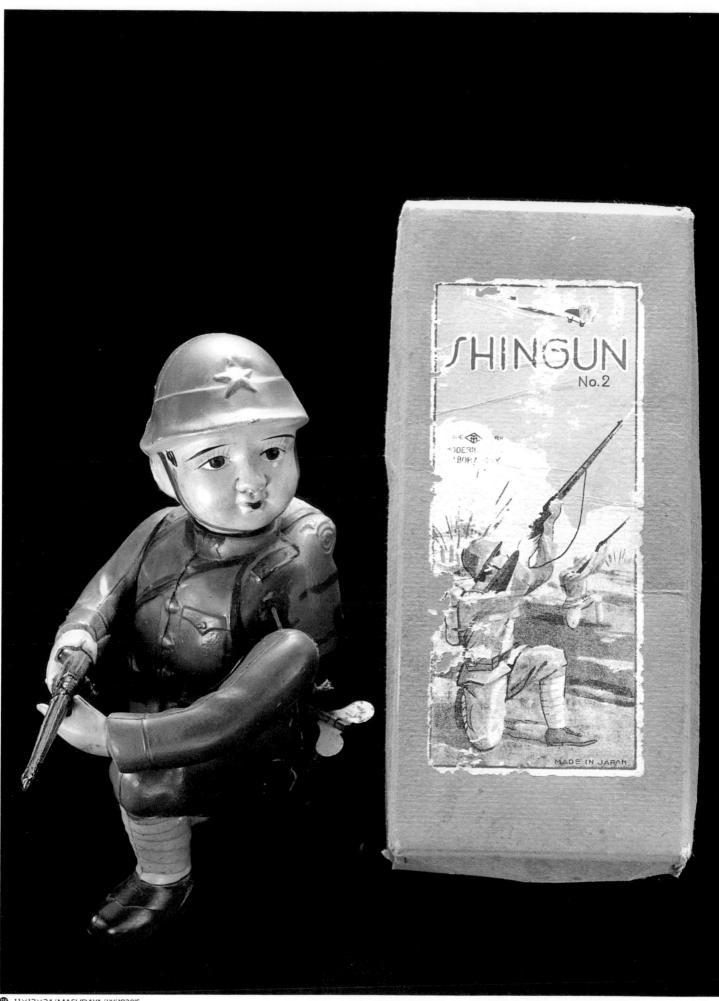

⑪ 11×12×24/MASUDAYA/W/1930'S

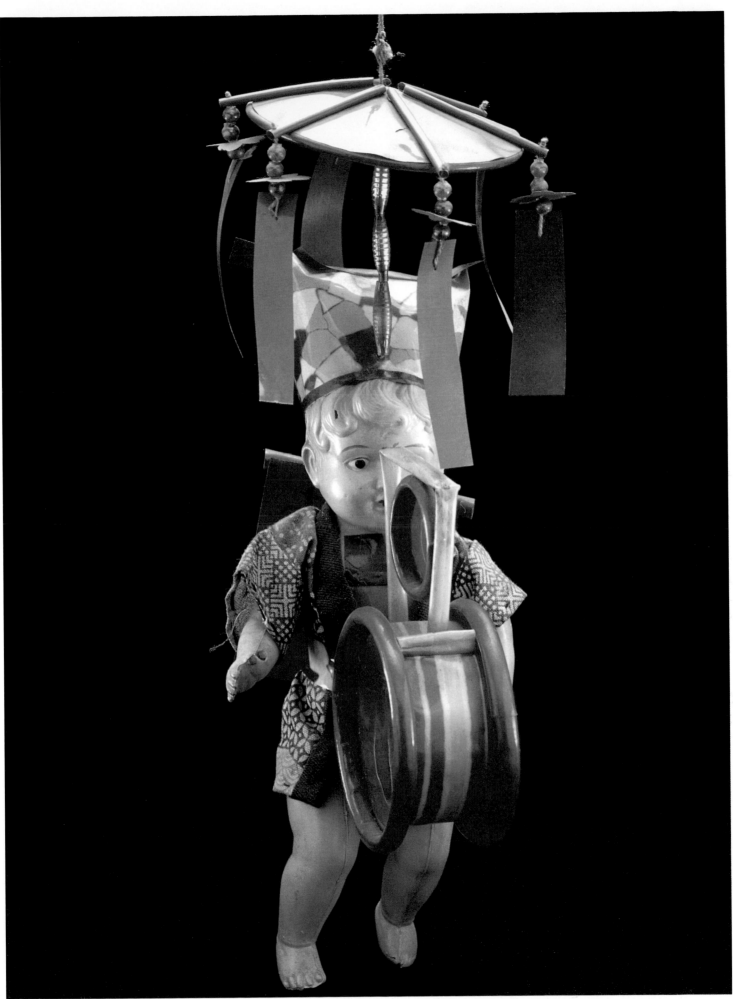

116 8×10×26/UNKNOWN/1930'S

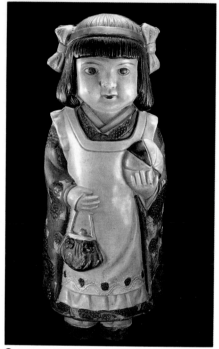

⑪⑱ 5.5×4.5×14.5/UNKNOWN/1930'S

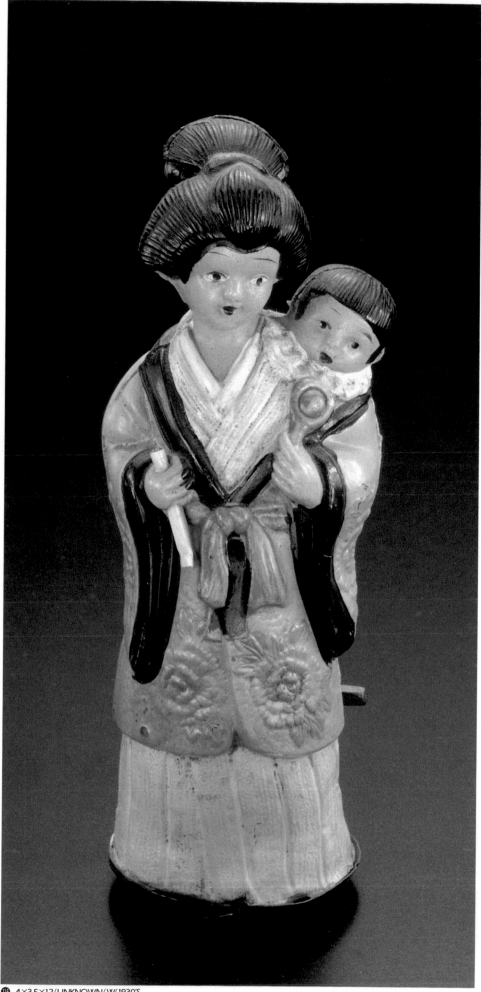

⑲ 9.5×6.5×24/UNKNOWN/1930'S

⑯ 4×3.5×12/UNKNOWN/W/1930'S

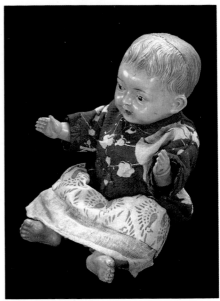

⑫ 9×6×18/UNKNOWN/1930'S

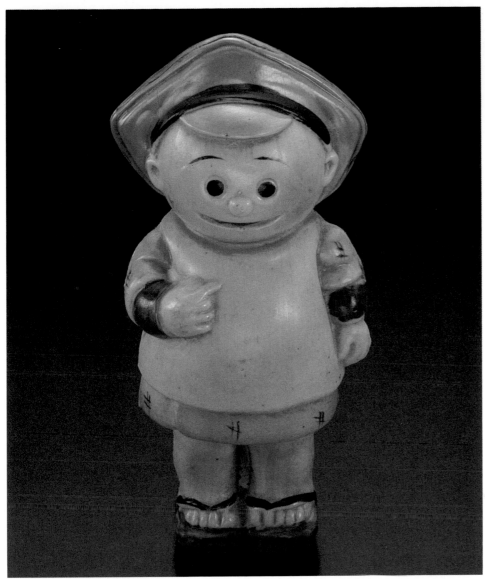

⑳ 4.5×4×10/UNKNOWN/1930'S

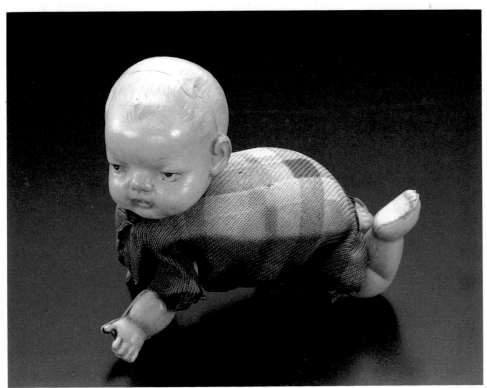

⑫ 9.5×5×7.5/UNKNOWN/W/1930'S

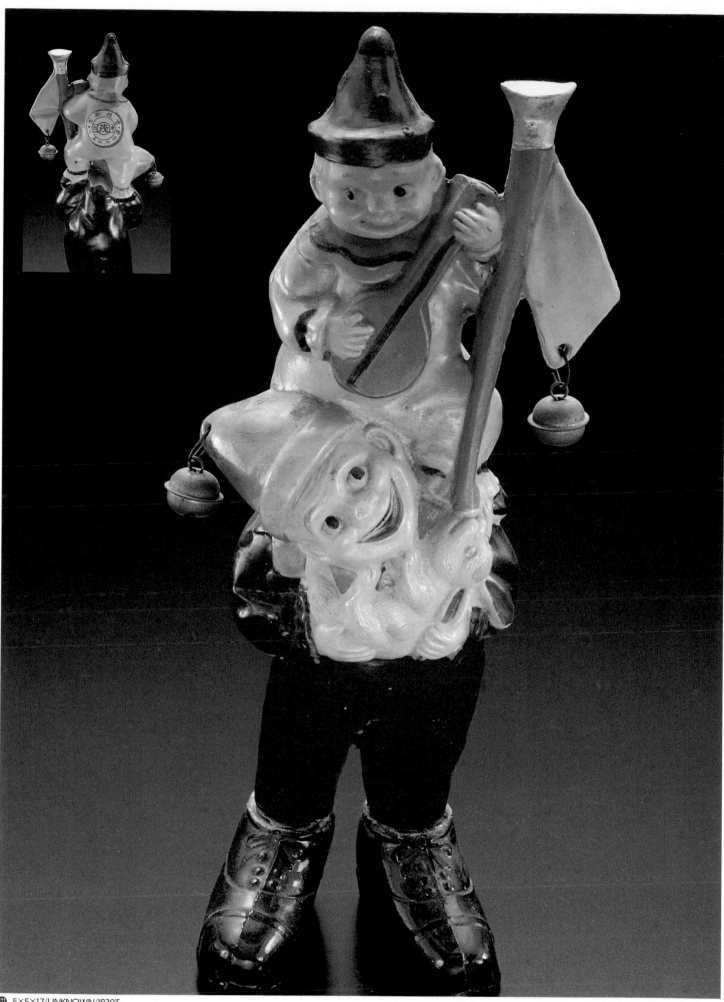

128 5×5×17/UNKNOWN/1930'S

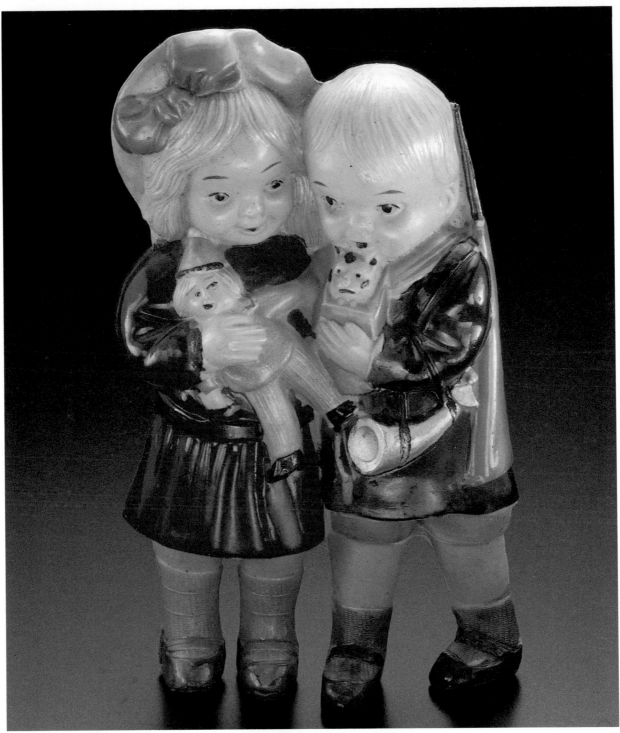

⑫ 8.5×4.5×14.5/UNKNOWN/1930'S

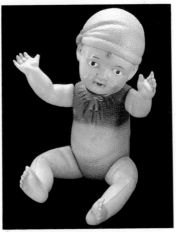

⑫ 9×6×20/UNKNOWN/1930'S

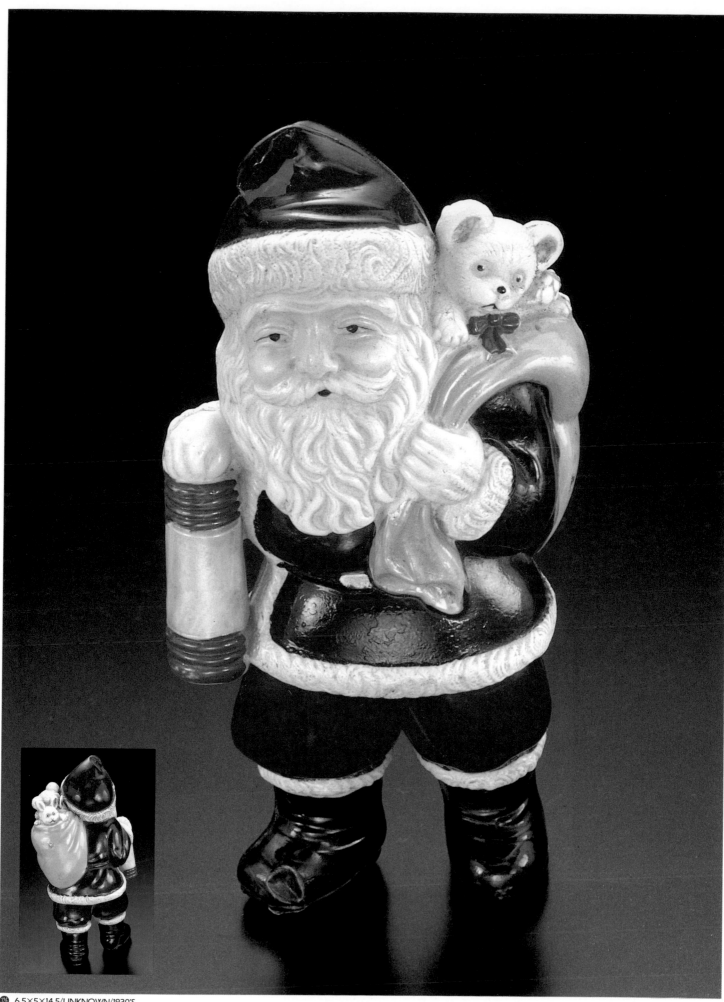

126 6.5×5×14.5/UNKNOWN/1930'S

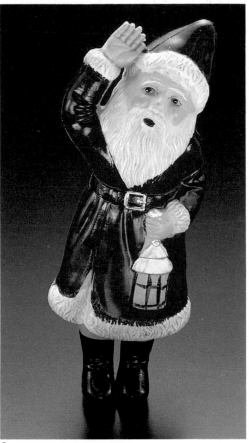

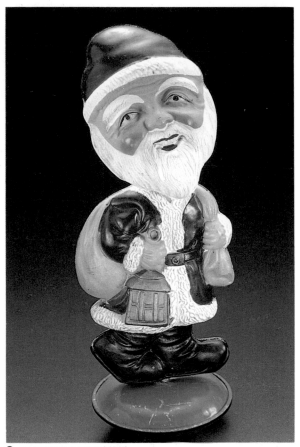

⑰ 6.5×6×17/UNKNOWN/1930'S

⑱ 7×6×17/UNKNOWN/1930'S

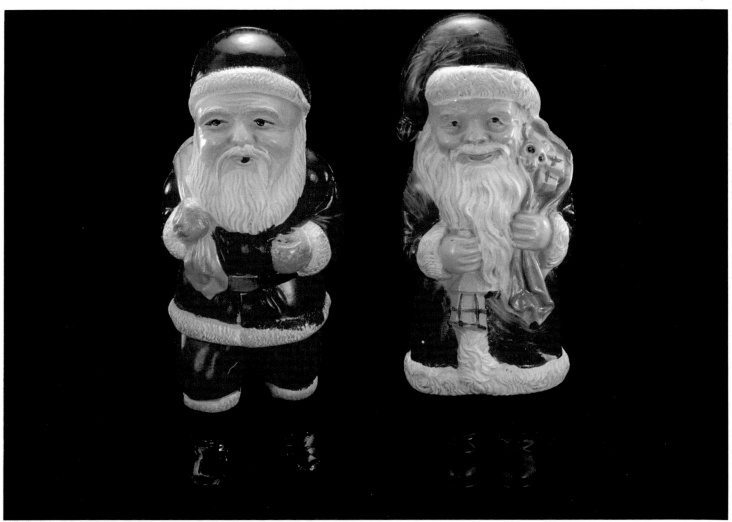

⑲⑳ 6×5×15/UNKNOWN/1930'S, 1940'S

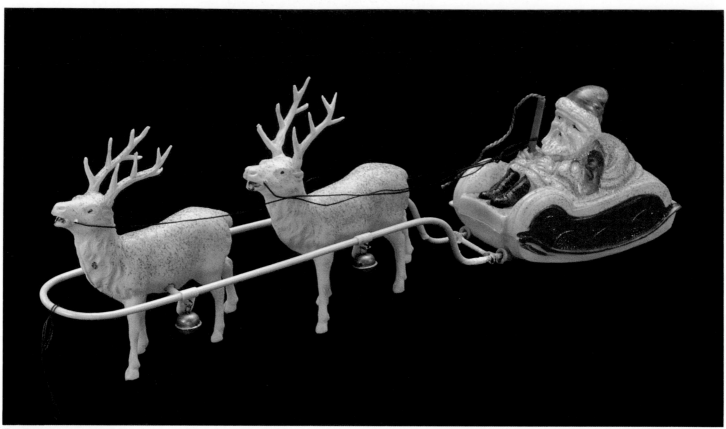

🔴131 5.5×30×7/UNKNOWN/1930'S

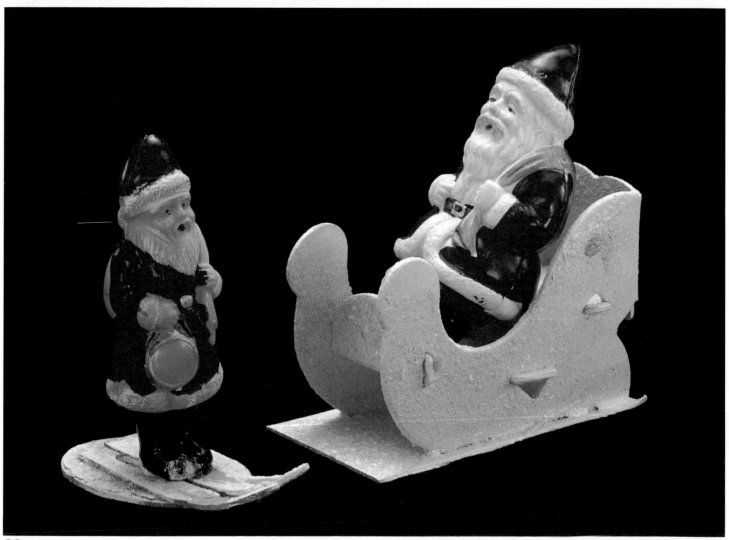

🔴132🔴133 4×8×9, 5×9.5×10/UNKNOWN/1930'S

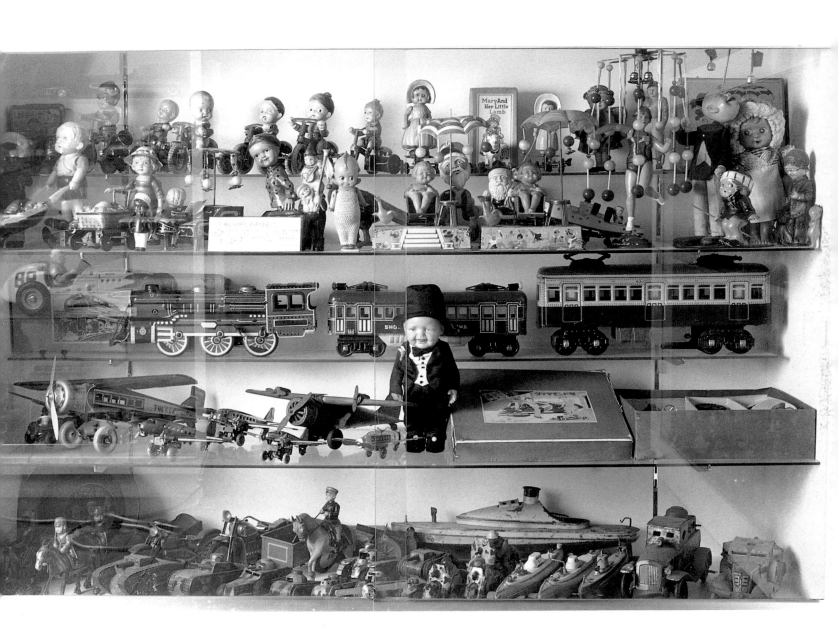

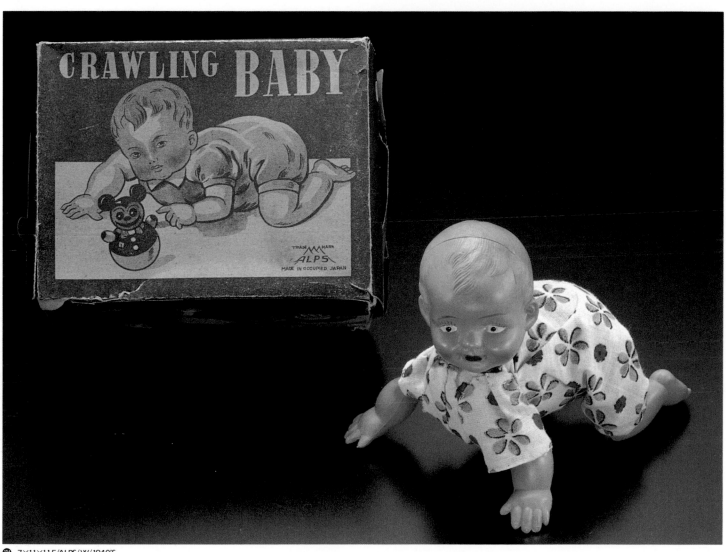

184 7×11×11.5/ALPS/W//1940'S

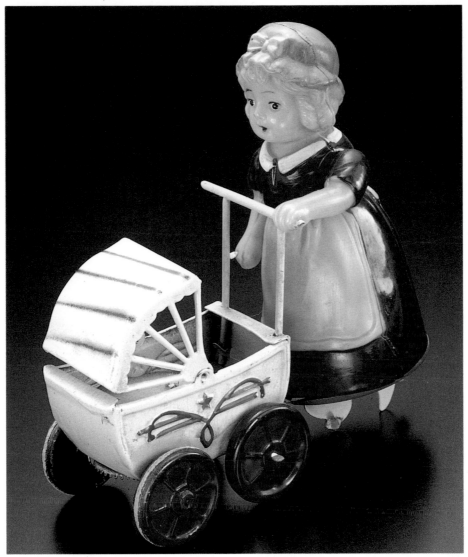

● 4.5×12×13/UNKNOWN/W/1940'S

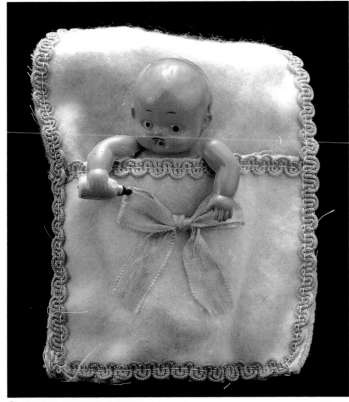

● 9.5×3×16/UNKNOWN/1940'S

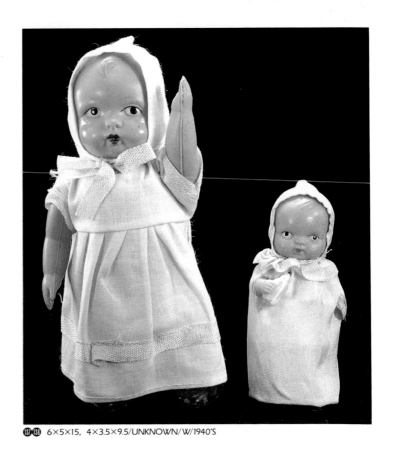

● ● 6×5×15, 4×3.5×9.5/UNKNOWN/W/1940'S

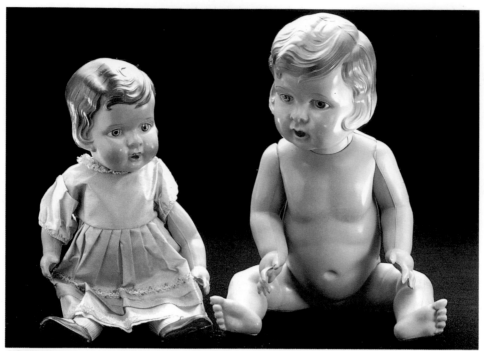

139 140 12×8×23, 13×8×29/SEKIGUCHI/1940'S

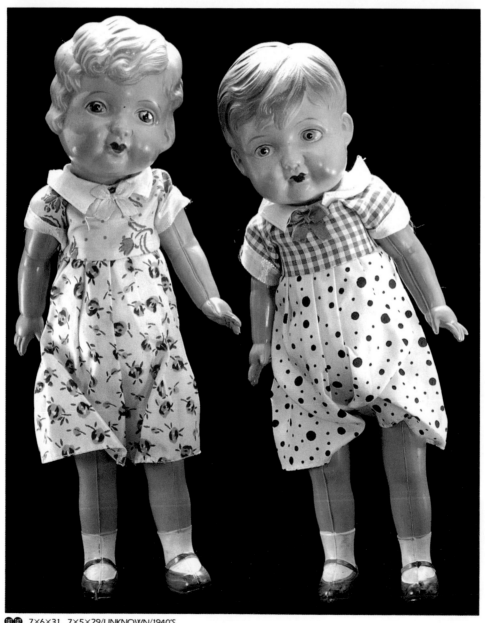

141 142 7×6×31, 7×5×29/UNKNOWN/1940'S

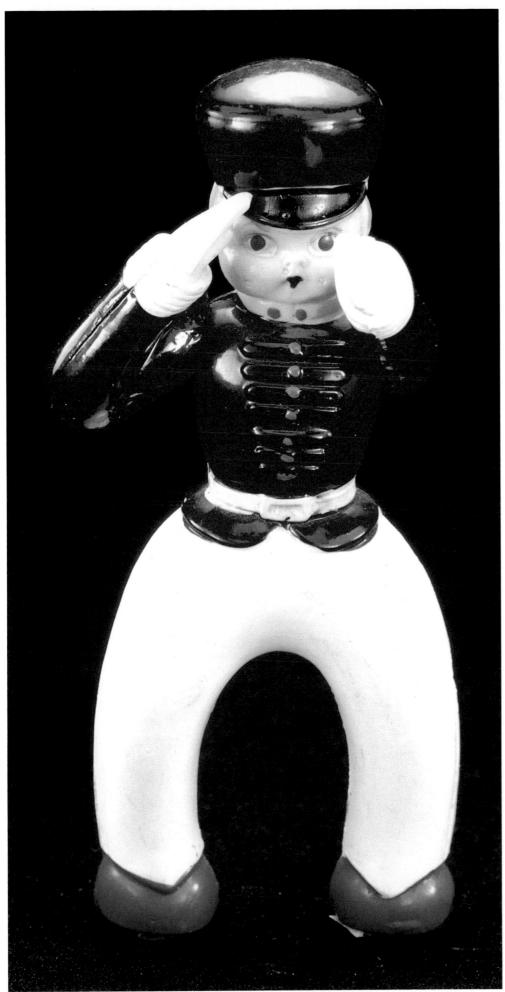

⑭⑶ 4.5×2×10.5/ROYAL/1940'S

⑭⑷ 6.5×4×16/UNKNOWN/1940'S

⑮ 6×9×11／UNKNOWN／W／1940'S

146 5×5×11/UNKNOWN/1940'S

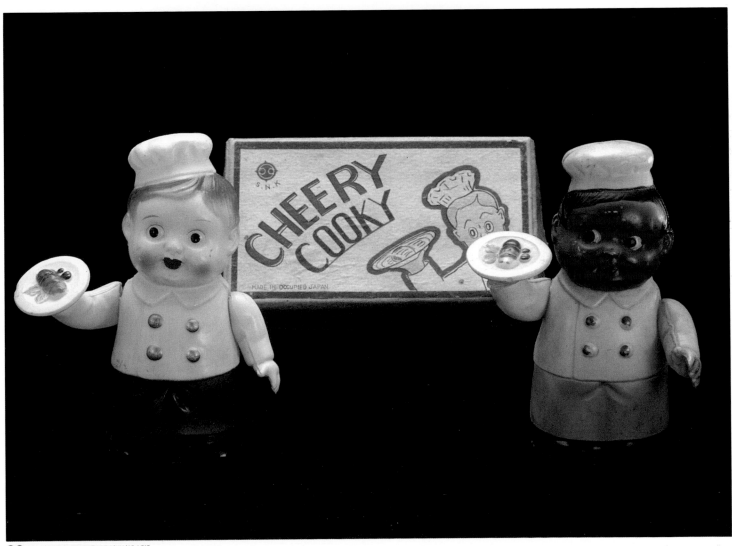

147 148 9×5×12/UNKNOWN/W/1940'S

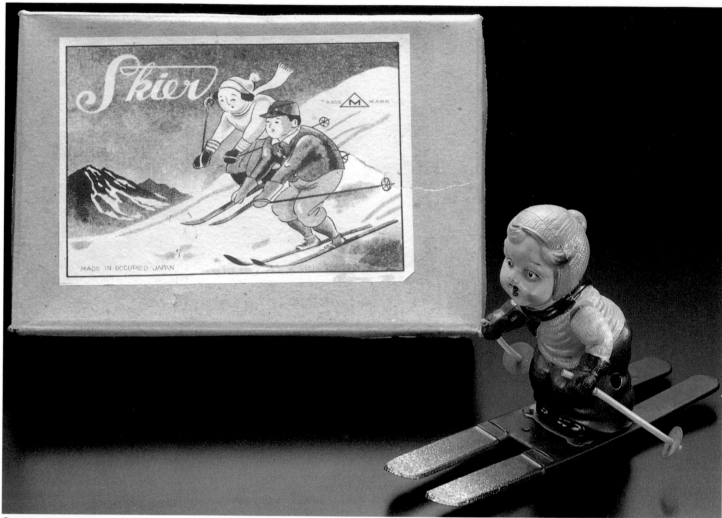

149 4.5×16×11/UNKNOWN/W/1940'S

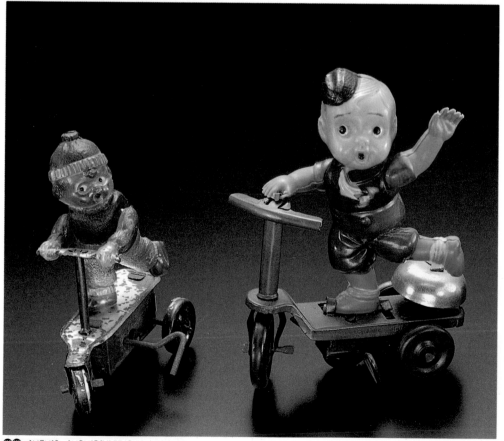

150・151 4×7×10, 4×9×12/UNKNOWN/W/1940'S

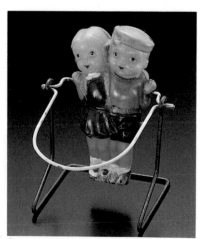

152 7×6.5×12.5/UNKNOWN/W/1940'S

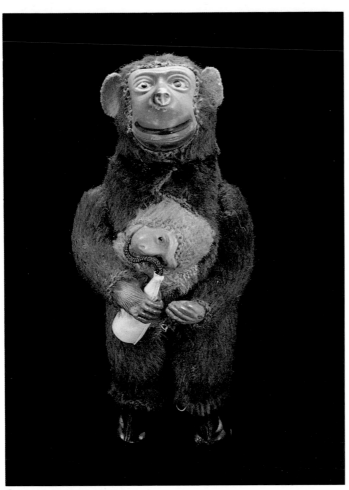

❶❸❹ 11.5×4.5×6/UNKNOWN/W/1940'S

❶❸❸ 6×6×13/UNKNOWN/W/1940'S

❶❸❺ 5×18×9/UNKNOWN/W/1940'S

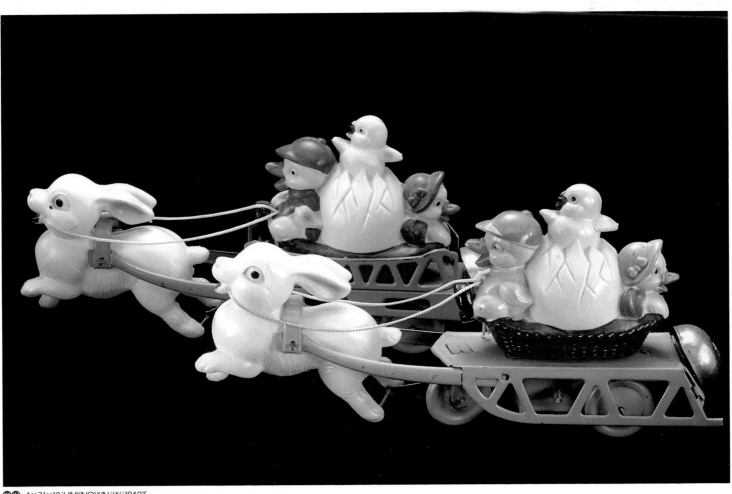

❶❺❻❶❺❼ 4×21×10/UNKNOWN/W/1940'S

⑮ 10.5×7×12/KOKYU SHOKAI/W//1940'S

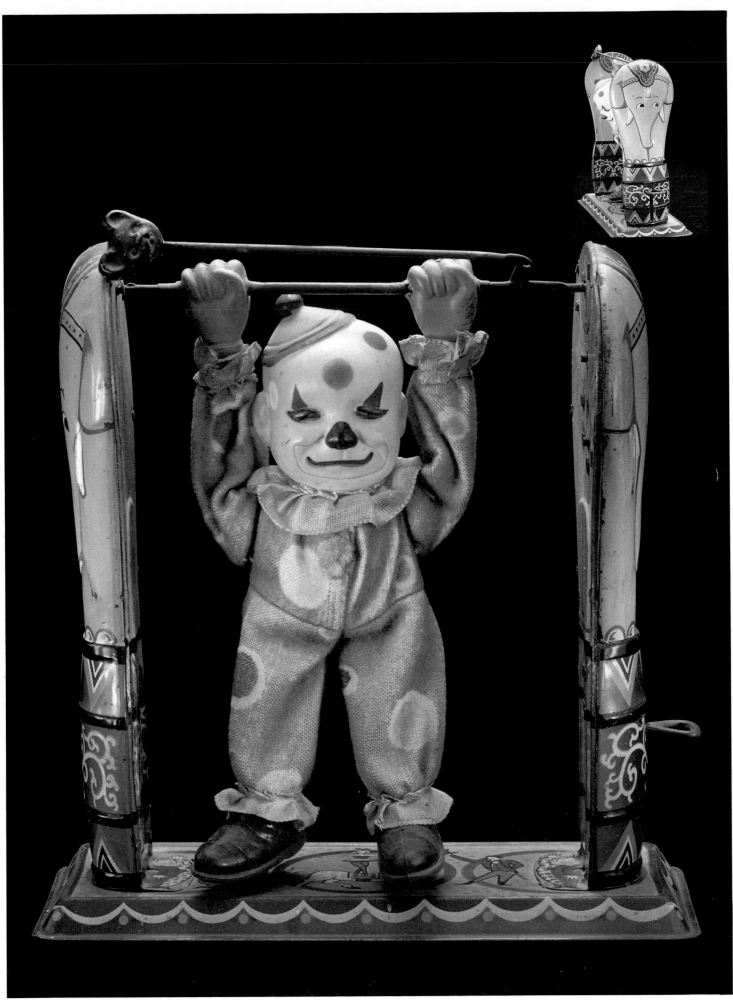

159 18.5×8.5×19/MASUDAYA/W//1950'S

⑯ 6.5×16×6/UNKNOWN/1950'S

⑯ 5.5×19.5×6/UNKNOWN/1950'S

⑯ 5×14×6/UNKNOWN/1950'S

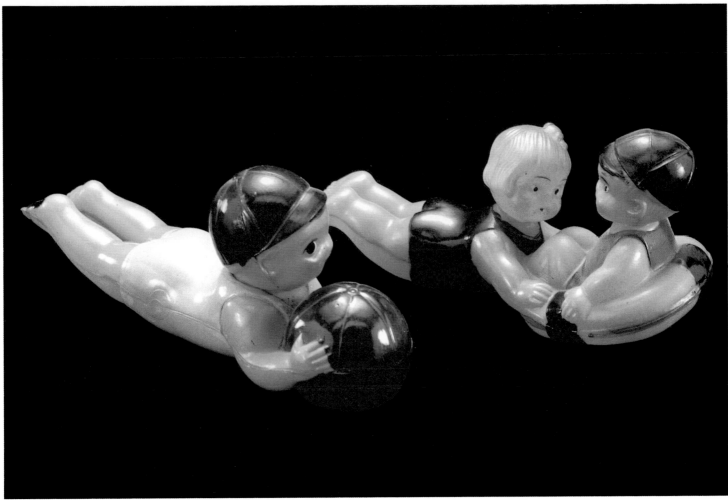

163 164 5×12×6.5/UNKNOWN/1950'S

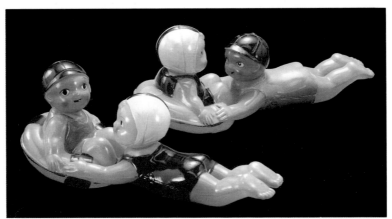

165 166 7.5×18×8/UNKNOWN/1950'S

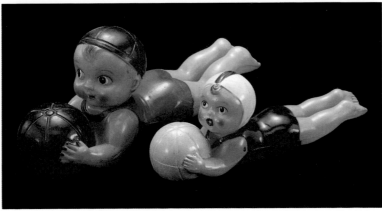

167 168 5.5×18×7.5, 3.5×14×6/UNKNOWN/1950'S

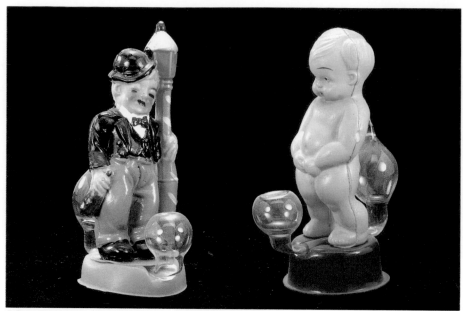

169·170 3.5×3.5×8/UNKNOWN/1950'S

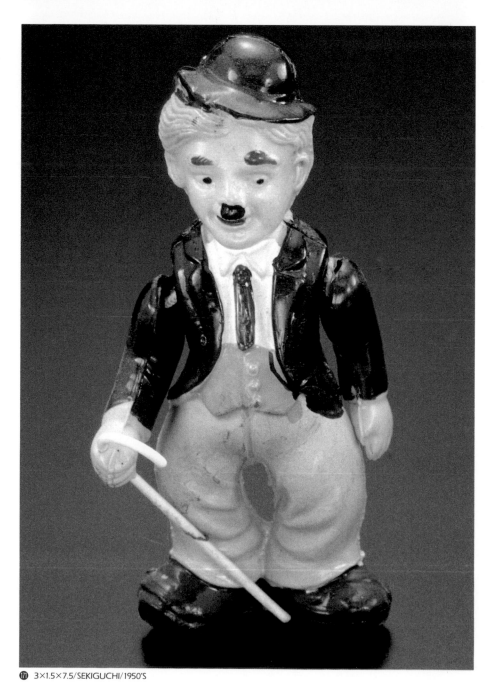

171 3×1.5×7.5/SEKIGUCHI/1950'S

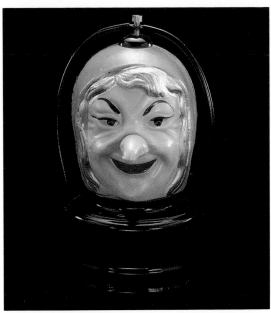

172 6×6×11/UNKNOWN/B/1950'S

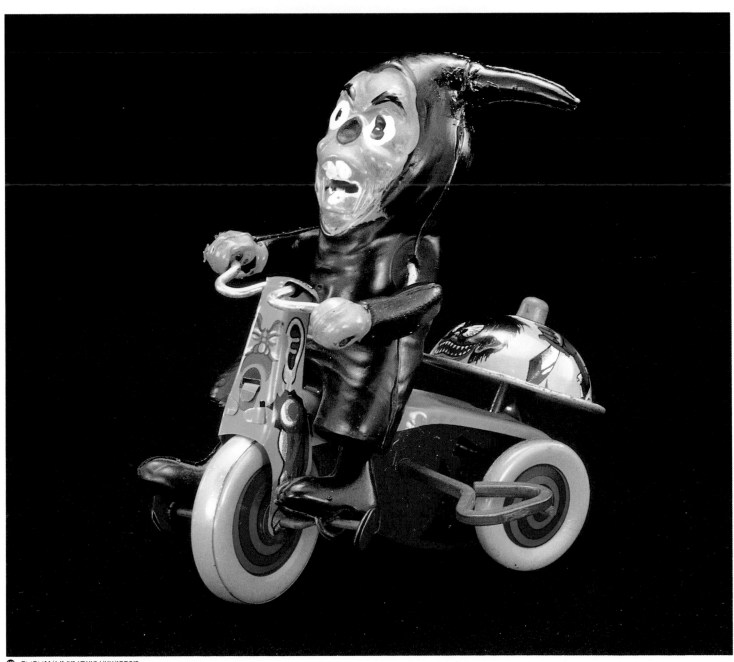

173 5×9×11/UNKNOWN/W//1950'S

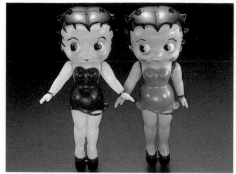

⑰⑰ 5×4.5×15/UNKNOWN/1950'S

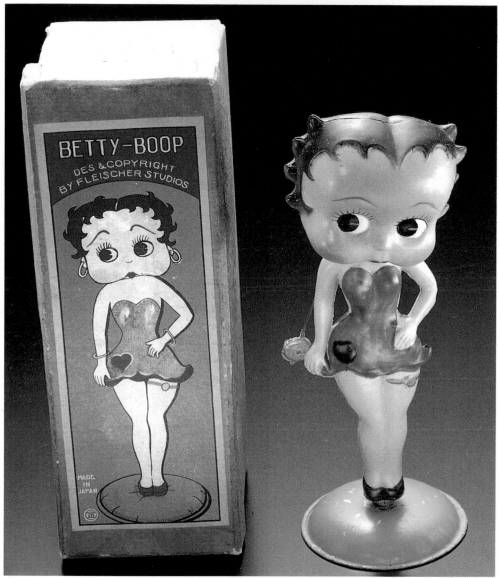

⑯ 6.5×6.5×17/UNKNOWN/1930'S

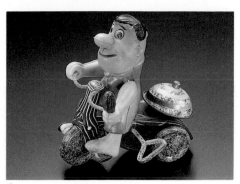

⑰ 5×9×11/LINE MAR/W/1950'S

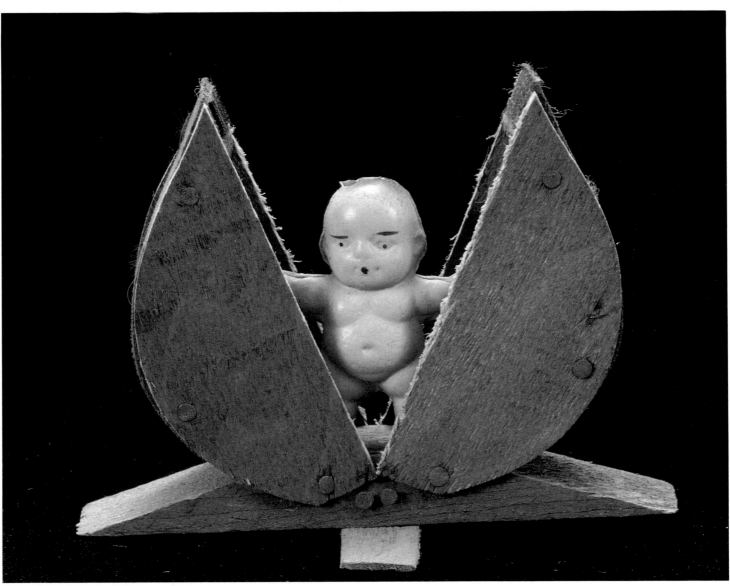

⑰ 8.5×2×6.5/UNKNOWN/1950'S

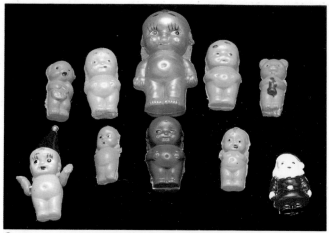

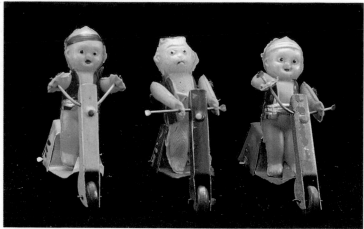

179 UNKNOWN/1950'S

180~182 2×7×6/UNKNOWN/1950'S

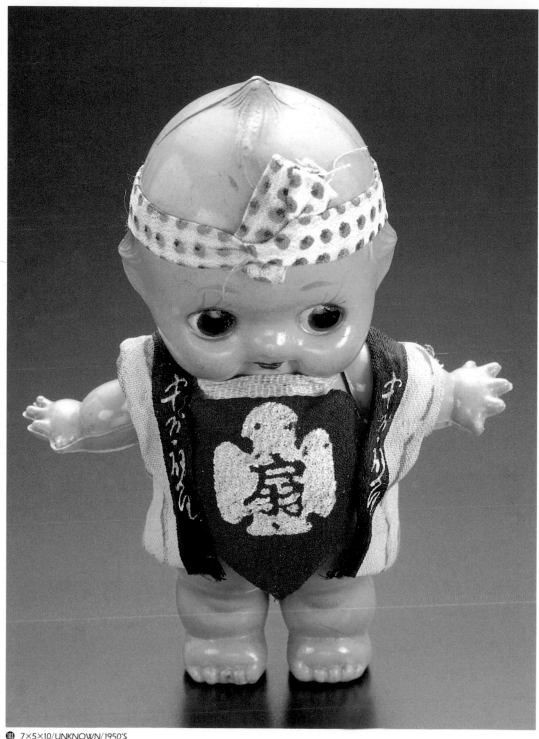

183 7×5×10/UNKNOWN/1950'S

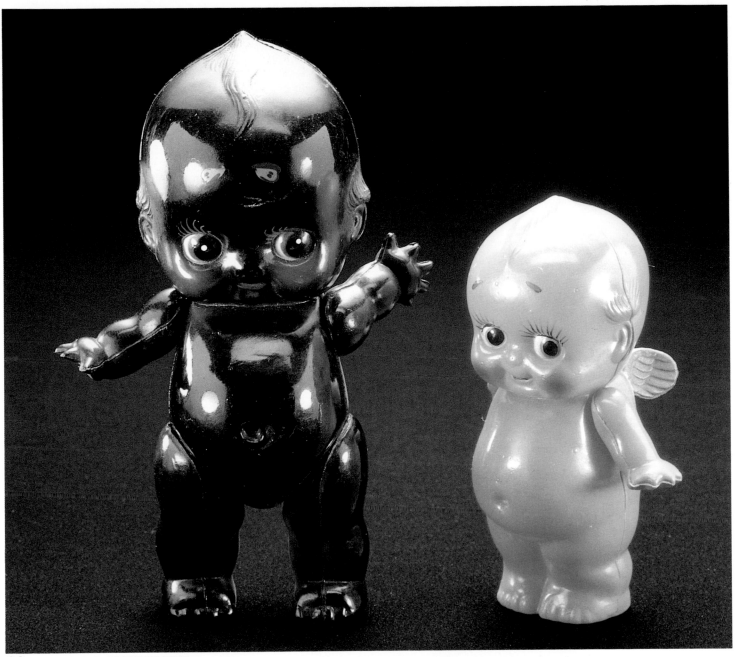

🔴184·185 7.5×5.5×17, 6×5×13/UNKNOWN/1950'S

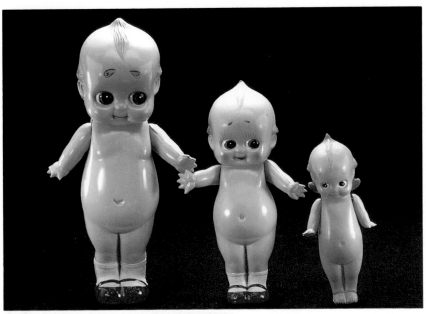

🔴186～188 7×6×25, 6×5×19.5, 4×3.5×15/UNKNOWN/1950'S

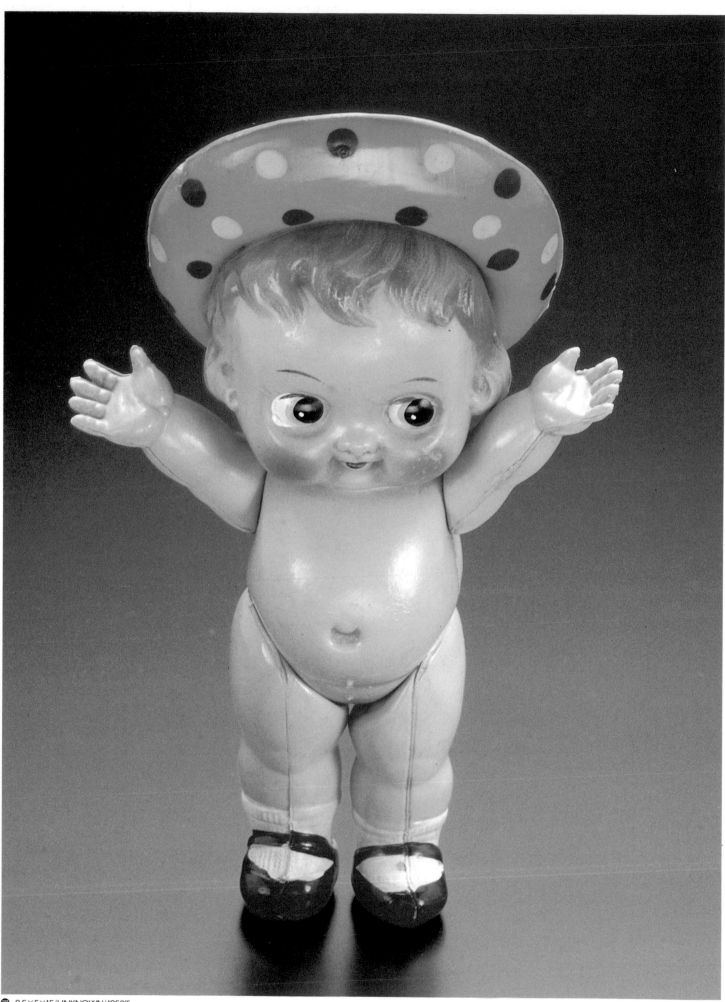

189 9.5×5×15/UNKNOWN/1950'S

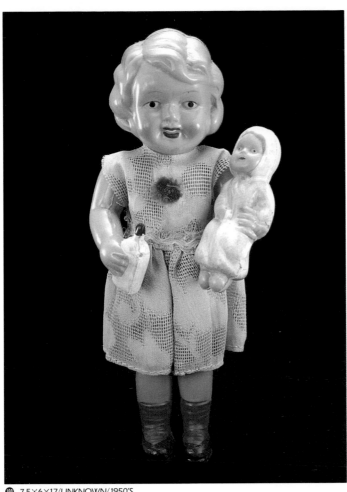

⑲ 7.5×6×17/UNKNOWN/1950'S

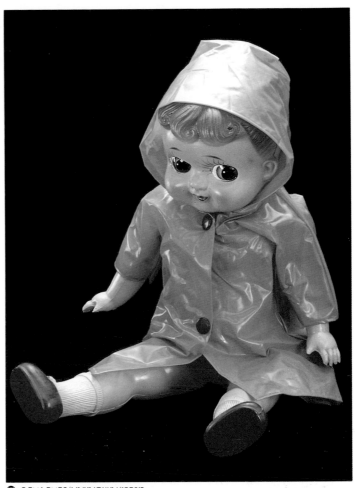

⑪ 8.5×6.5×20/UNKNOWN/1950'S

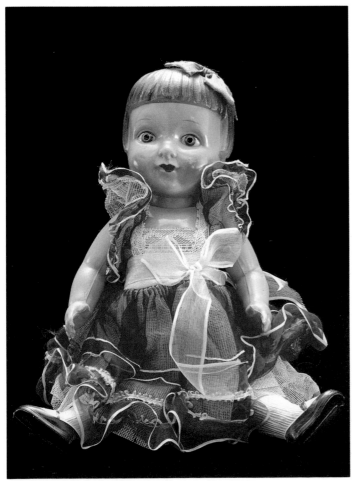

⑫ 12×11×25/SEKIGUCHI/1950'S

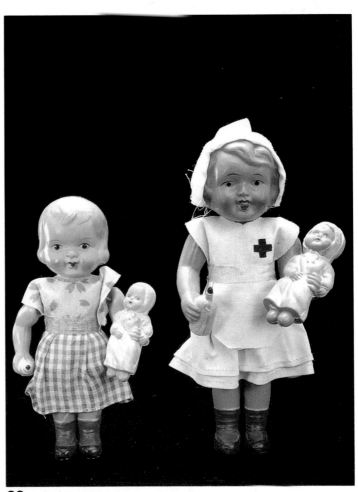

⑬⑭ 4×3×13.5, 6×3.5×17/UNKNOWN/1950'S

⑲⑤ 14×8×28/UNKNOWN/1950'S

⑲⑥ 6.5×6.5×11.5/UNKNOWN/1950'S

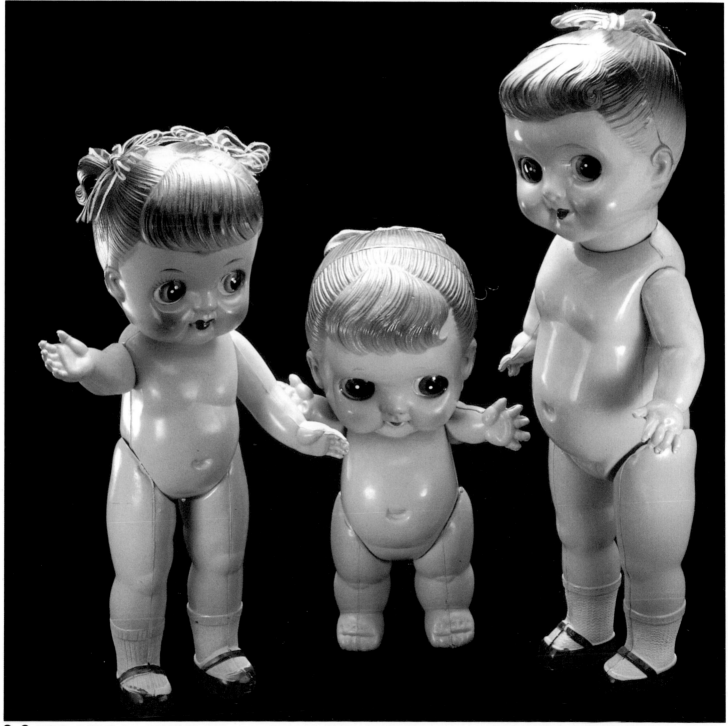

⑲⑦～⑲⑨ 6×5×26, 6×5.5×19, 7×6×30/UNKNOWN/1950'S

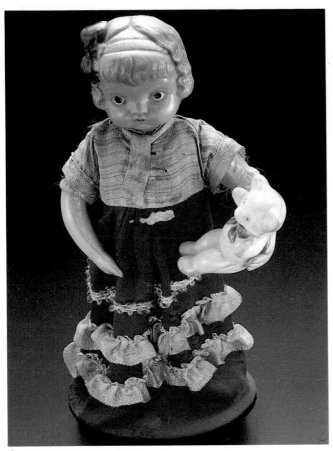

200 7.5×7.5×17/UNKNOWN/1950'S

201·202 5×5×17, 6×5×20/UNKNOWN/1950'S

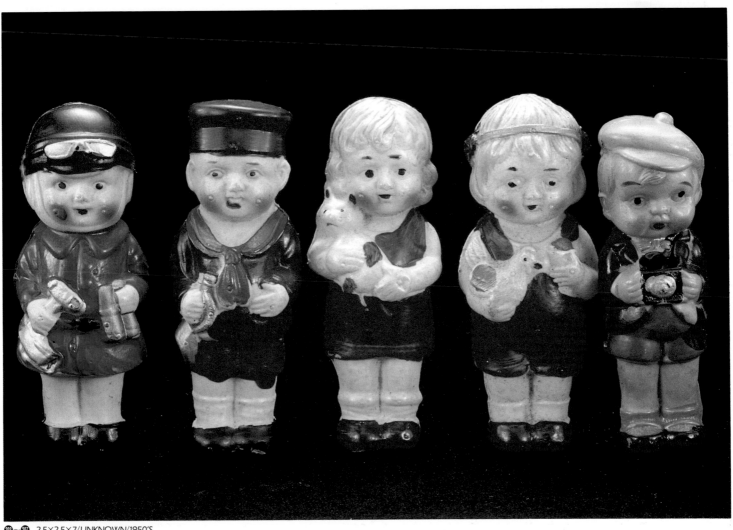

203～207 2.5×2.5×7/UNKNOWN/1950'S

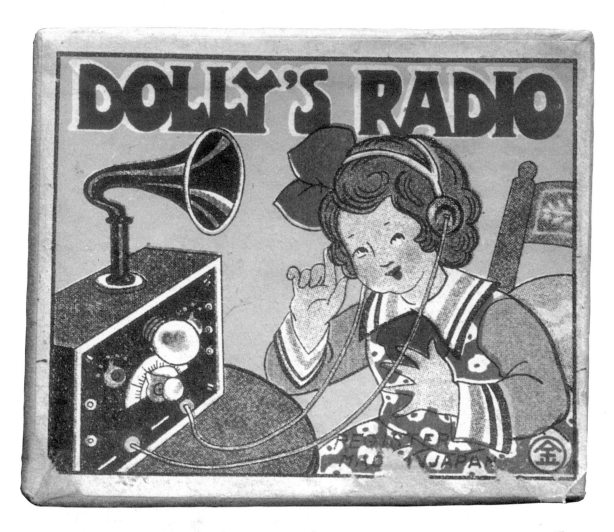

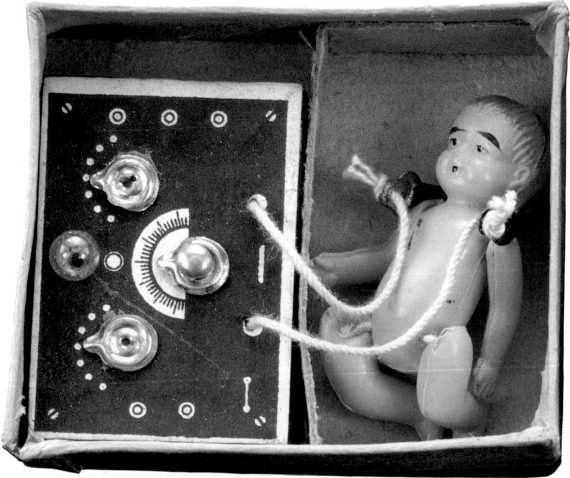

⑳ 8×6.5×3/MARUGANE/1950'S

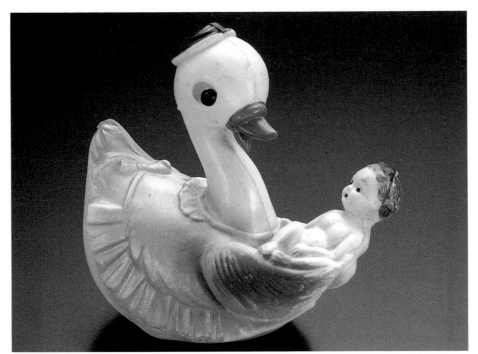

⑳ 7×10×10/UNKNOWN/1950'S

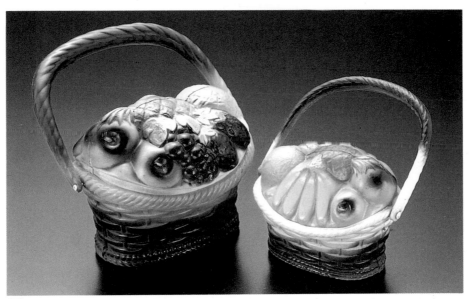

⑩⑪ 11×9×9, 9×7×6.5/UNKNOWN/1950'S

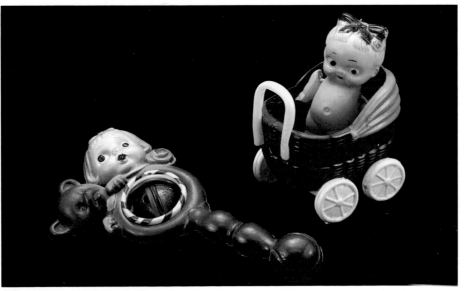

⑫⑬ 6×3.5×13, 5×7×6/UNKNOWN/1950'S

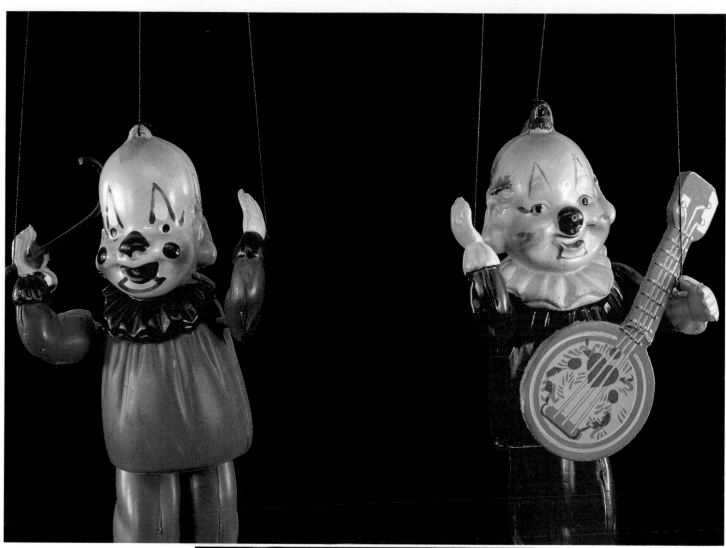

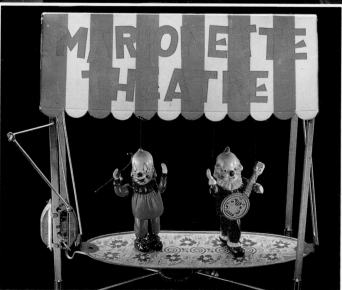

214 22.5×11×28/UNKNOWN/W/1950'S

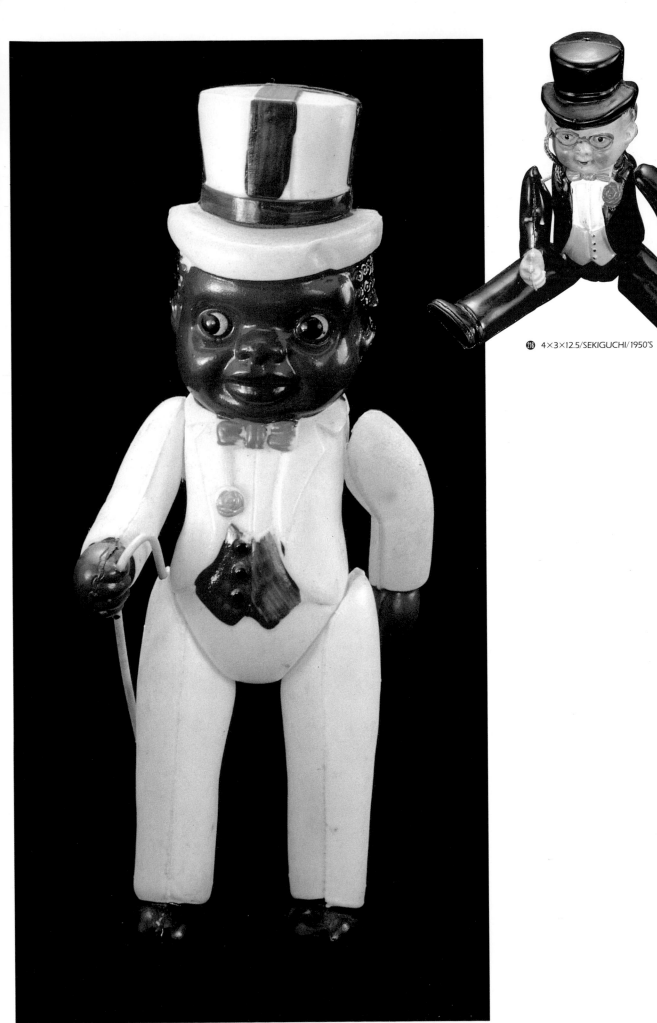

216 4×3×12.5/SEKIGUCHI/1950'S

215 4×3×15/UNKNOWN/1950'S

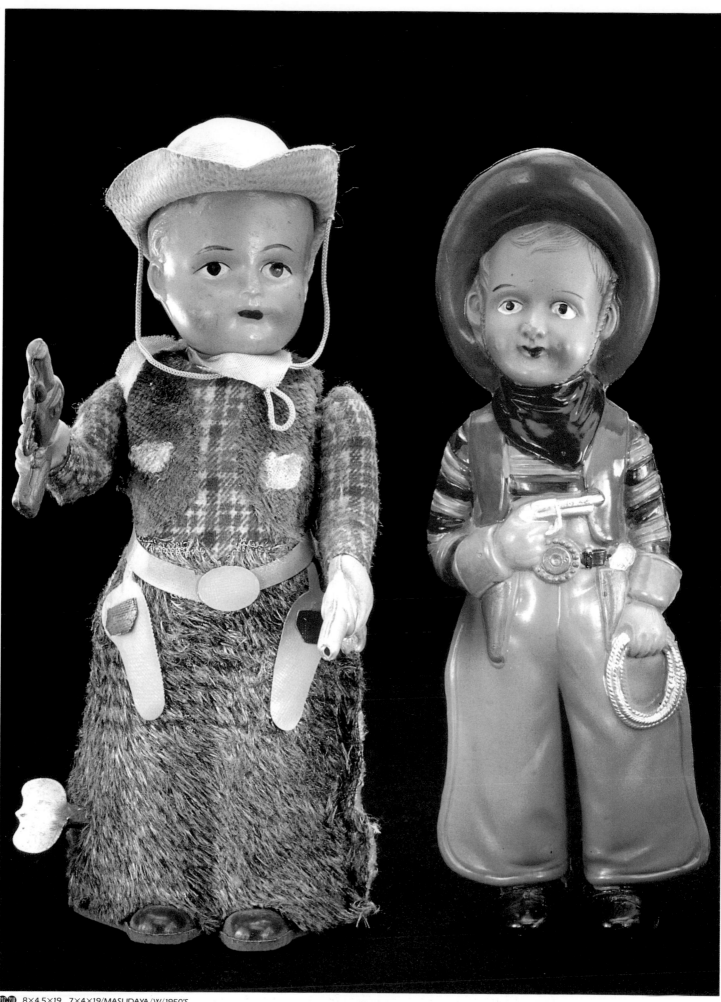

217 218 8×4.5×19, 7×4×19/MASUDAYA/W/1950'S

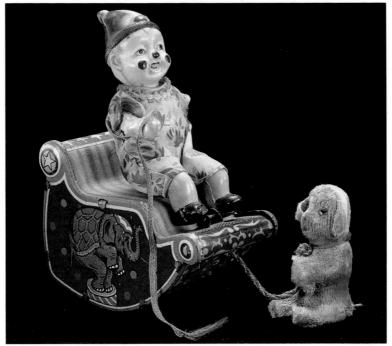

㉑㊈ 6×10×14/UNKNOWN/F/1950'S

㉒㉑ 3×3×6.5, 4×3×6/UNKNOWN/1950'S

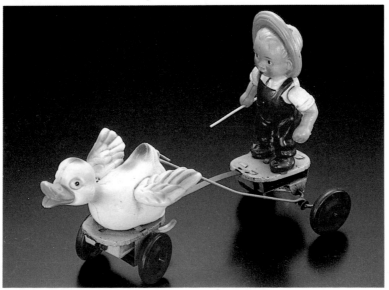

㉒㉒ 18×6.5×13/UNKNOWN/W/1950'S

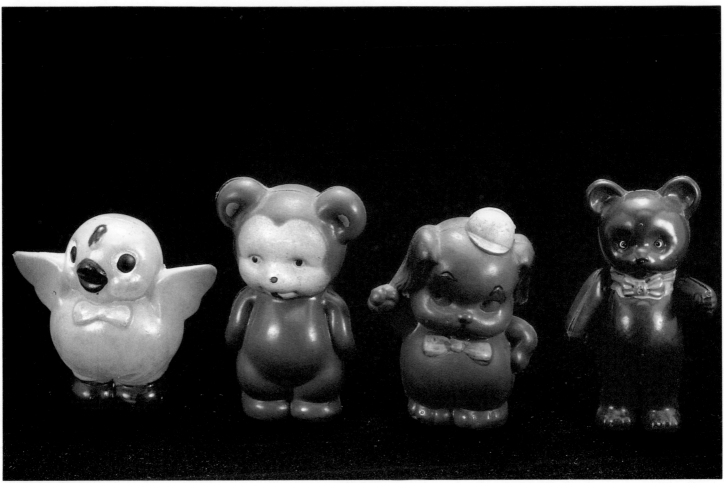

223～226 3.5×2.5×6/UNKNOWN/1950'S

227 1×1.5×2/UNKNOWN/1950'S

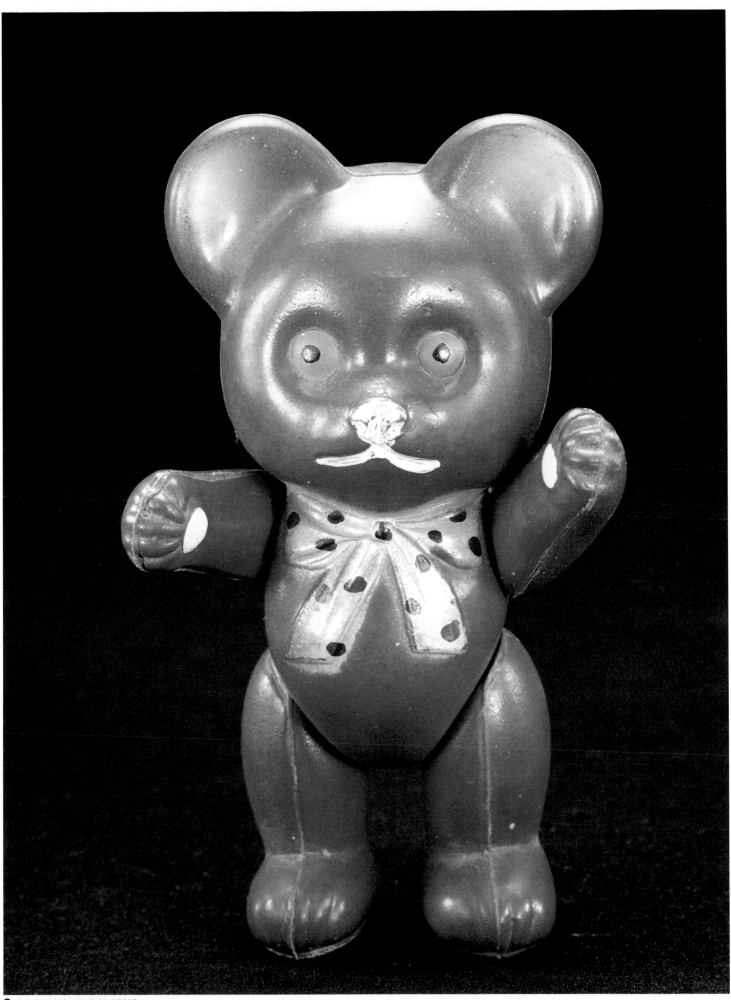

270 3.5×3.5×10/UNKNOWN/1950'S

223 1.5×2×2/UNKNOWN/1950'S

EXPLANATION

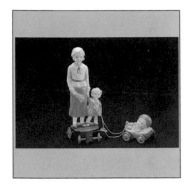

Figure 2 (wind-up): This toy was made in the 1930s. The fashion trends of the times are apparent in the clothing that the mother and child are wearing.

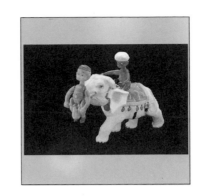

Figure 7 (wind-up): Henry, a cartoon character, rides on the trunk of an elephant. The elephant's legs move by vibration, as do its head and ears. The elephant is particularly realistic.

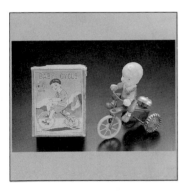

Figure 3 (wind-up): The way in which these figures turn around— "dancing"—is certainly cute. There have been many types of dancing dolls, but this model was made before the war. Social dancing was very popular then.

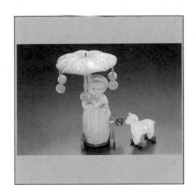

Figures 8 and 9: Figures 8 and 9 were constructed in the thirties. The lamb moves along beside Mary, nodding its head like a papier-mache tiger.

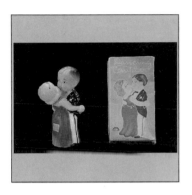

Figure 4 (wind-up): This toy clangs and pedals furiously when wound up. This toy has been designed with great attention to detail, and such a fantastic facial expression rarely appears in these toys.

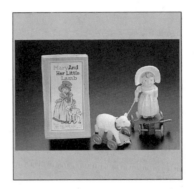

Figure 10 (wind-up): When wound, the umbrella revolves. The popularity of this model continued for a long time.

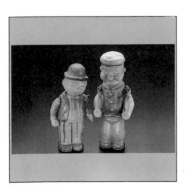

Figures 5 and 6 (wind-up): Figure 5's forward motion is created by vibrations coming from within the toy. The same system has been used for the Popeye in Figure 6. Celluloid was chosen for this toy because it is so light. Wimpy can bow.

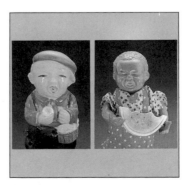

Figures 11 and 12 (wind-up): The children, with dogs snapping at their behinds, shed tears and run. This realistic toy might have had more popularity among adults than among children.

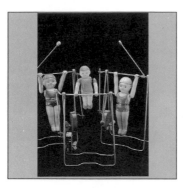

Figures 13 through 23 (wind-up): These trapeze toys were designed by Masayoshi Fujii. The dolls make quick and realistic gymnastic movements. It was a popular toy before the war, and its popularity has continued right up to the present day.

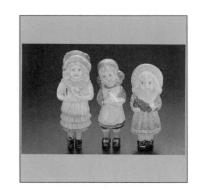

Figures 28 through 38: These dolls have no movable parts. All were made before the war. After the war, such realistic faces and clothes disappeared. The parasol in Figure 38 is especially beautifully made.

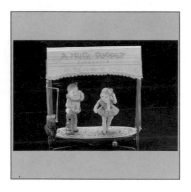

Figure 24 (wind-up): The movement of the disc underneath the theater makes it look as though the two cute dolls dressed in clown suits are dancing around on the stage.

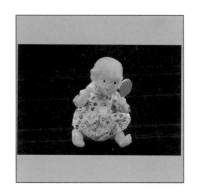

Figure 39 (wind-up): This doll powders her face. She seems to be awfully precooious for her age, but the awkwardness of her movements makes her rather sweet.

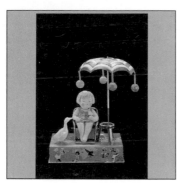

Figure 25 (wind-up): The deck chair in which the little girl sits rocks gently back and forth, and the parasol and duck revolve. A very peaceful scene indeed.

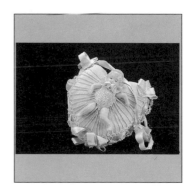

Figure 42: This doll has no movable parts. The combination of a baby and cushion is quite unusual. Presumably, it was used as a wall decoration.

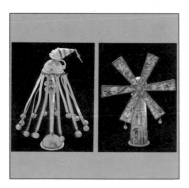

Figures 26 and 27 (wind-up): Both of these toys move on a rotary basis. When the clown is spun around, the rattles spread out due to centrifugal force. The same principle has been used for the windmill and its bells. These toys were made especially for very small children.

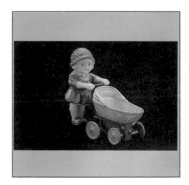

Figure 43: The doll follows the baby carriage. The shapes and details of both the carriage and the doll are exceptionally well done.

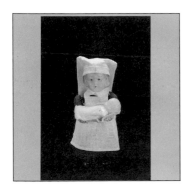

Figure 44 (wind-up): The nurse/doll tries to keep the baby amused by moving her arms up and down.

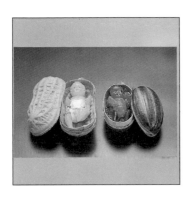

Figures 45 and 46: These celluloids are Christmas tree decorations. The peanut and watermelon open to reveal babies inside.

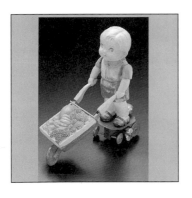

Figure 52 (wind-up): Every piece of fruit in the wheelbarrow was modeled and painted by hand. It must have taken hours. Owing to the fact that each part was hand painted, the colors differ from fruit to fruit.

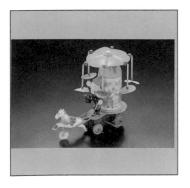

Figure 53 (wind-up): The clown makes a comical face while he sits on top of the rattle that is being pulled by the horse. When the rattle revolves, the hanging ornaments spread out and the music starts.

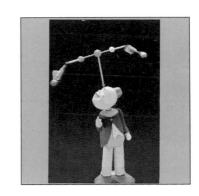

Figure 54 (wind-up): This figure balances on his forehead a rotating baton atop a wooden pedestal. The act of balancing seems almost real in this contorted figure.

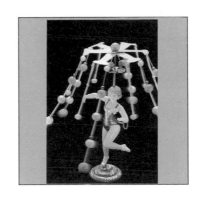

Figure 55 (wind-up): When the dancer in the center revolves, centrifugal force sends the attached balls spreading out around her. It is a truly beautiful sight. Such an attractive effect could only be produced in the medium of celluloid.

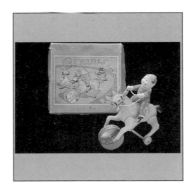

Figure 56 (wind-up): The horse moves forward by leaping up and down due to the fact that its hooves are attached to wheels.

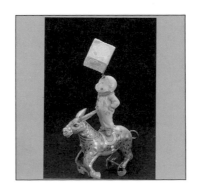

Figure 57 (wind-up): As the horse advances via vibrations, the box the clown balances on his forehead revolves. The horse is made of tinplate, the clown of celluloid, and the box of paper.

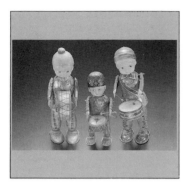

Figures 58 through 62 (wind-up): These drummers were created before the second World War and display various mechanical methods. Figure 60 drums by means of vibrations that run through its body; the others hit their drums with independently moving arms.

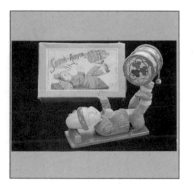

Figure 63 (wind-up): The baby lying on its back shakes its head back and forth while revolving the drum by the alternate use of both its arms and its legs. The stitches of the child's sweater are rendered in great detail.

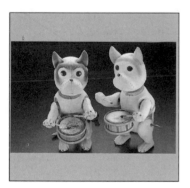

Figures 64 and 65 (wind-up): The model for this dog playing the drum is taken from a television cartoon character. It nods its head while playing the drum.

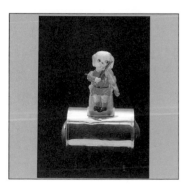

Figure 66 (wind-up): This figure has moving hands and head. The box underneath contains a music-box device.

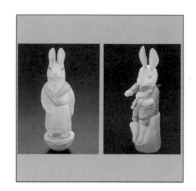

Figures 67 and 68: Celluloid toys made before the war have exceptionally realistic facial features—Figure 67 has more expression than rabbits generally have. Figure 68 produces music in the same way that Figure 66 does. It also moves its arms and ears.

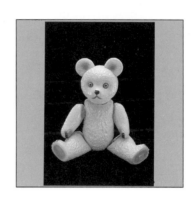

Figure 69: No part of this figure is movable. It is quite an unusual color for a bear. It's not such a loud color; really, it's a very pleasant shade of green. It also has a lovely face and fur.

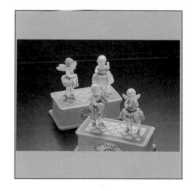

Figures 71 and 72: These little angels dance around. They are operated by a bellows that is connected to a wire that projects from the bottom of the box.

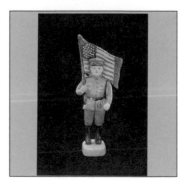

Figures 76 through 79: These figurines have no movable parts. Soldiers and boy scouts such as these were made in Japan for export use. It is interesting to note that these patriotic toys were made in Japan.

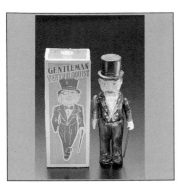

Figure 81 (wind-up): This "Gentleman Ventriloquist" was the prototype for Edgar Bergen's Charlie McCarthy. It moves by means of vibrations while opening and closing its mouth.

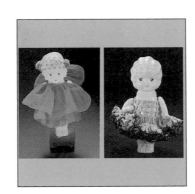

Figures 91 and 92: These celluloid dolls are elaborately clothed in painstakingly worked dresses.

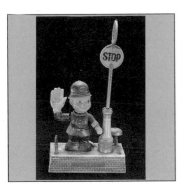

Figures 82 and 83: Figure 82 does not move. The authoritative position of its hand is maintained by means of sand inside, which acts as ballast. Figure 83 is a wind-up. It moves its hand in accordance with the traffic signal next to it.

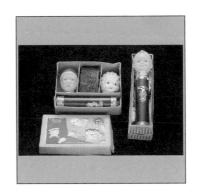

Figures 93 and 94: These celluloid dolls' heads were to be attached to the head of a flashlight. This was not really a practical idea, considering celluloid's inflammability, but the heads could be changed, and the package came with a bulb-cleaning brush.

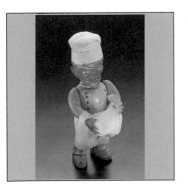

Figure 84: This peculiar figure moves forward by vibration while raising and lowering his chicken, which seems to be struggling to free itself.

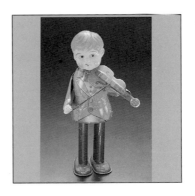

Figure 100 (wind-up): This model rocks its body from right to left while playing the violin. The head is made of celluloid, but the rest is tinplate.

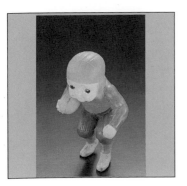

Figures 88 through 90: These dolls give an indication of the style of the outfits that prewar athletes used to wear.

Figure 104: These toys were quite common at fairs after the war, but this particular model was made before the war. The camphor is inserted in the stern of the boat, and it is then set in the water. As the camphor dissolves in the water, it propels the celluloid boat forward.

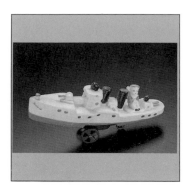

Figure 105 (wind-up): This model boat actually moves along the ground on wheels. The the striking difference of scale between the fishermen and the boat is fascinating.

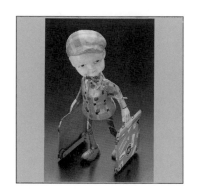

Figure 110 (wind-up): This traveler appears to be pulling along two suitcases. In fact, the suitcases are supporting the figure as it moves along step by step.

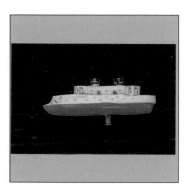

Figure 106: This figure is a Christmas ornament. It can be lit by a lamp which is placed inside. When it glows in the dark, one can almost imagine the happy cries of the passengers and the lapping of the waves against the hull.

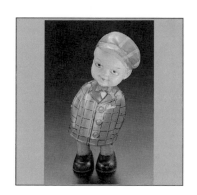

Figure 111 (wind-up): This toy was used as an advertment. Although it is quite ordinary in its movements, its facial expression and tartan check coat stick in people's minds.

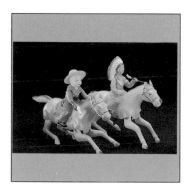

Figures 107 and 108 (wind-up): When they are placed on the floor fully wound up, these horses will move forward with vigorous jerks of their legs. The legs will not move unless they are brought into contact with the floor.

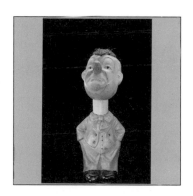

Figure 112 (wind-up): The head of this clown shakes up and down and around. His pathetic expression seems very realistic.

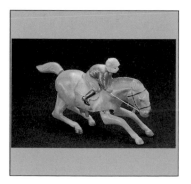

Figure 109 (wind-up): Going by the blue ribbon attached, it is a safe assumption that this particular model was destined for export to Great Britain.

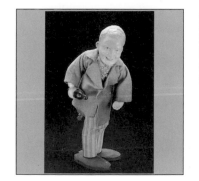

Figure 113 (wind-up): This figure lurches and twists its body around in imitation of a drunk. It holds a glass in its left hand and a bottle of beer in its right. Its legs are made of wood, while the rest of its body is celluloid.

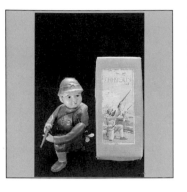

Figure 114 (wind-up): This toy soldier was made during the war; he moves his head from right to left while raising and lowering his rifle. The wartime milieu is apparent from the picture on the box.

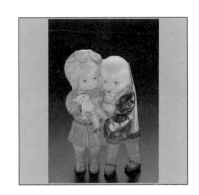

Figure 124: This figurine has no movable parts. One of the figures carries a rifle and a trumpet. It was obviously made during the war.

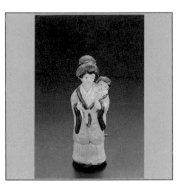

Figure 116 (wind-up): This figure moves forward on the wheels under its feet, stops to turn around, and then advances again. These toys were made for distribution within Japan.

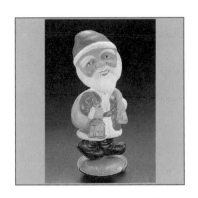

Figures 126 through 133: The face of Figure 128 moves from left to right by means of elastic and a pendulum. Apart from this, none of the figures have movable parts. All of these Santa Clauses were made before the war.

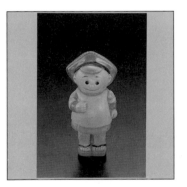

Figure 120: This little figure, a cartoon character, does not move.

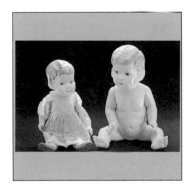

Figures 139 through 144: All of these toys were made in occupied Japan. During that time, all Japanese manufacturers were obliged to print "Made in Occupied Japan" on each product. This obligation continued from 1945 to 1950. None of these figures have movable parts.

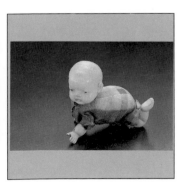

Figure 122 (wind-up): This Japanese baby crawls along while shaking its head from side to side. This particular model was made before the war, but the concept continued in production afterwards.

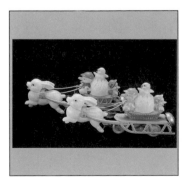

Figures 145 through 157: All of these toys were made in occupied Japan, and they are all wind-ups. Figures 155 through 157 were Easter toys and were made for export.

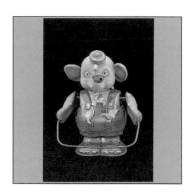

Figure 158 (wind-up): Made in the 1950s, this elephant jumping rope is rather comical. The realistic facial features include such details as the wrinkles on the elephant's nose. The patterns on its clothes are also very cute.

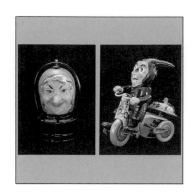

Figure 172 and 173: Both of these figures are Halloween toys. The witch's face lights up for a particularly creepy effect.

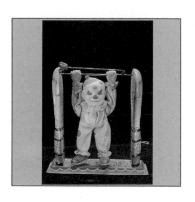

Figure 159 (wind-up): This swinging clown was made in the 1950s. The posts of his sturdy-looking trapeze are decorated with elephants, but, nonetheless, the clown has a melancholy expression on his face.

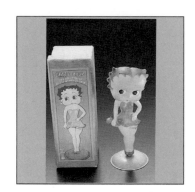

Figures 174 through 176: Figures 174 and 175 were produced in the 1950s and do not move. Figure 176 is a creation of the 1930s and nods its head backwards and forwards by the means of elastic and a pendulum.

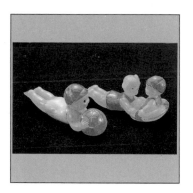

Figures 160 through 168: These little dolls were meant to be bath toys. There were many such toys produced, but unfortunately, celluloid melts in hot water, so these toys have become quite rare.

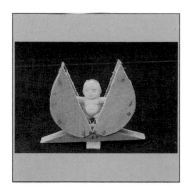

Figure 178: This celluloid doll, representing the legendary Japanese character Momotaro, bursts from a peach made of wood. When closed, an adhesive holds the sections together for approximately ten seconds before the hero pushes his way out again.

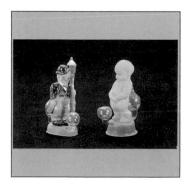

Figure 170: A glass tube containing realistically colored liquid is placed on the back of each of these figures. The warmth generated by a hand holding this tube causes air pressure which ejects the liquid out the front of the tube. The result is a slightly more prurient version of the baby doll who wets.

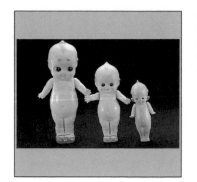

Figures 179 through 188: These celluloid Kewpie dolls were made after World War II. They are brighter and more appealing than the prewar models.

Figure 208: Dolly's Radio, featuring a baby doll with headphones, has very detailed knobs and dials.

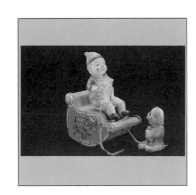

Figure 219: The movement of the rocking chair in which the clown is seated slowly pulls the dog towards it, giving the impression of mysterious forces.

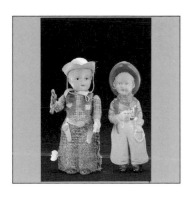

Figures 217 and 218: Figure 217 is a wind-up. The hand holding the pistol moves up and down while the cowboy's head moves from side to side. Figure 218 has no movable parts.

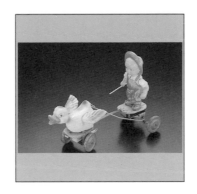

Figure 222: The duck quacks by means of a bellows system. The movement of a child chasing a bird is well expressed by the spring which connects the child to the bird.

CELLULOID TOYS

It is much more difficult to find celluloid toys in good condition than to find tin toys in good condition. Due to the characteristics of the material, it is almost impossible to prevent discoloration and dents in celluloid toys. However, when celluloid dolls are arranged in a display case, the damage seems to fade, and they become innocent, warm, and gentle, as if they had melted into the lives of the people who doubtless loved them and owned them for many years. Celluloid dolls seem to be exhausted by sadness, but when I look at them not as a collector but as a human being, I sense in their distorted forms all the love they have absorbed. In this way, celluloid toys are different from the other toys I have collected. For example, I was recently given a green celluloid teddy bear that I had long coveted. It was owned by an American; I had tried to ask this friend for the bear before, but he was very attached to it and I was quickly refused. The reason he finally gave it to me was not to embellish my collection, but to signify that he was my friend.

—*Teruhisa Kitahara*